A CLOSER LOOK

· · · · · · · · · · ·

The Antebellum Photographs of Jay Dearborn Edwards

1858·1861

Curated by
JOHN H. LAWRENCE
JOHN T. MAGILL
PAMELA D. ARCENEAUX

Edited by
JESSICA DORMAN
ERIN GREENWALD

THE HISTORIC NEW ORLEANS COLLECTION
NEW ORLEANS, LOUISIANA

HARDWARE

AYAN & CARHART.

LOTHING

72 72

AREHOUSE.

STRAW GOODS ANDREW G. BULL & C?

MERCANTILE AGENCY SADDLES &c.

57 C. H. SLOCOMB & C? 57

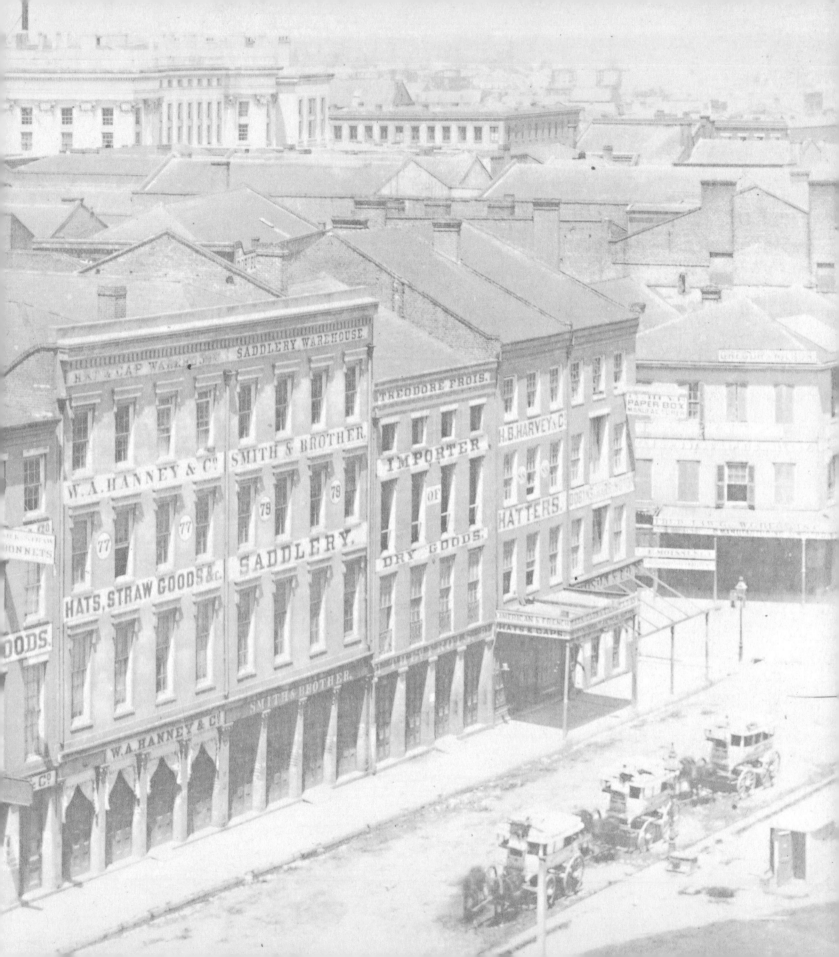

The Historic New Orleans Collection is a museum, research center, and publisher dedicated to the study and preservation of the history of New Orleans and the Gulf South region. The Collection is operated by the Kemper and Leila Williams Foundation, a Louisiana nonprofit corporation.

Published on the occasion of the exhibition *A Closer Look: The Antebellum Photographs of Jay Dearborn Edwards, 1858–1861* at The Historic New Orleans Collection, October 1, 2008– February 20, 2009.

Library of Congress Cataloging-in-Publication Data

Edwards, J. D. (Jay Dearborn), 1831-1900.
 A closer look : the antebellum photographs of Jay Dearborn Edwards, 1858-1861 : an exhibition at the Historic New Orleans Collection, October 1, 2008-February 20, 2009/ curated by John H. Lawrence, John T. Magill, Pamela D. Arceneaux ; edited by Jessica Dorman, Erin Greenwald.
 p. cm.

 Includes bibliographical references and index.

 ISBN 978-0-917860-52-2 (alk. paper)

 1. New Orleans (La.) —History—19th century— Pictorial works—Exhibitions. 2. Neighborhood— Louisiana—New Orleans—History—19th century— Pictorial works—Exhibitions. 3. Historic buildings— Louisiana—New Orleans—Pictorial works—Exhibitions. 4. Historic sites—Louisiana—New Orleans—Pictorial works—Exhibitions. 5. New Orleans (La.) —Buildings, structures etc. —Pictorial works Exhibitions. 6. Edwards, J. D. (Jay Dearborn), 1831-1900—Exhibitions. 7. Photography—Louisiana—New Orleans—History— 19th century—Exhibitions. 8. Collodion process— Louisiana—New Orleans—History—19th century— Exhibitions.

 I. Lawrence, John H. II. Magill, John T. III. Arceneaux, Pamela D. IV. Dorman, Jessica. V. Greenwald, Erin. VI. Historic New Orleans Collection. VII. Title.

F379.N543E34 2008
976.3'350507476335—dc22

 2008035772
 CIP

©2008 The Historic New Orleans Collection
533 Royal Street
New Orleans, Louisiana 70130
www.hnoc.org

First edition. 2,000 copies
All rights reserved
Printed by Harvey-Hauser, New Orleans, Louisiana

FRONT COVER ILLUSTRATION: *South Claiborne Avenue at Common Street*, between 1858 and 1861; salted paper photoprint; Jay Dearborn Edwards, photographer, The Historic New Orleans Collection (1982.32.13)

PREVIOUS PAGE ILLUSTRATION: *500 Block of Canal Street, South Side* (Detail), 1859; salted paper photoprint; Jay Dearborn Edwards, photographer, The Historic New Orleans Collection (1982.167.1)

PHOTOGRAPHS COMMUNICATE IN ONE DIRECTION: FROM THE PAST, WHERE THEIR CONTENT RESIDES, TO THE PRESENT. THEY ARE FIXED. IT IS WE, THE VIEWERS, WHO CHANGE.

Even though early photographs depicted ostensibly familiar subjects, they presented the viewer—quite literally—with something never before seen. Hybrids of pure science and pure miracle, they inspired both trust and awe. Unlike other art forms, which more readily revealed the hand of the creator, early photographs were embraced for their ability to tell (or reveal) the truth. Deception, of course, has been part of photography's baggage since its invention. But this quality was more apparent to early practitioners than to early audiences.

Then as well as now, part of the unadulterated pleasure of looking at photographs resides in their potential to conjure a myriad of responses. By definition, responses will vary, given an individual's bank of personal memories or areas of curiosity. Indeed, a viewer may mine or glean information from a photograph that has little to do with its maker's intent. To encourage—and to chart—multiple paths of inquiry is the curatorial premise of *A Closer Look: The Antebellum Photographs of Jay Dearborn Edwards, 1858–1861.*

The body of work left by Jay Dearborn Edwards is not materially different from that of many others who practiced the craft and art of early photography. Edwards used no secret formulas, no special cameras—only the tools and techniques of a working professional. It was his subject, the South's largest city, that sets his work apart. Edwards made several dozen photographs of New Orleans—undoubtedly more are waiting to be unearthed—within a span of fewer than five years. These images pique our interest for their rendition of a specific place at a more-or-less single moment in time. And they represent, at least to this date, the earliest known photographic views on paper depicting the city of New Orleans.

VIEWS OF NEW ORLEANS--No. 49

J. D. Edwards' Gallery of Photographic Art,

NEW ORLEANS, LA.

The photographs on display in *A Closer Look*, together with a handful of others currently archived at other institutions, seem to be the remnant of a more substantial group. A numbering system on the prints suggests an original compilation of at least 118 views, assuming sequencing without gaps. Little is known about why these images were made. Like other professional photographers, then and now, Edwards made pictures of those people, places, and things that others paid him to record. But he seems to have exercised at least some degree of artistic agency. His business was advertised as a "gallery" with an assortment of pictures to be viewed and purchased—suggesting that Edwards anticipated the desires of his clientele, perhaps even shaping those desires with images made of his own volition.

The New Orleans of the late 1850s and early 1860s, the period of Edwards's residency, was a thriving port city. The 1860 census placed the population at 168,675 people. A glance at *Gardner's New Orleans Directory* of 1859 reveals the city's multifaceted commercial character. There were 237 attorneys, 53 notaries, 31 cotton brokers, and 6 dealers in slaves. Listings for commission merchants occupied 4 double-columned directory pages. Eight libraries had a combined 31,826 books on hand. Locksmiths and bellhangers numbered 20, harnessmakers 7, wheelwrights 6, and somnambulists 3. Those needing the services of a boilermaker could choose from among 5 listings. Single entries sufficed for real estate agents, artificial-leg makers, bung and plug manufacturers, mosquito-bar makers, and whitewashers. There were 3 listings for daguerreotypists and ambrotypists; "photographer" was not yet a category.

Cotton and sugar were the primary commodities fueling activity along New Orleans's levees and within the city's offices, banks, exchanges, and other halls of commerce. The 1861 *Gardner's* directory recapitulates the important role of the port in handling these cargoes. Between 1855 and 1858, the port of New Orleans regularly handled in excess of 50 percent of the national (that is to say, southern) cotton crop. The 1859–60 cotton harvest, the largest on record to date, produced 4.65 million bales—of which 2.25 million passed through the port of New Orleans.

With few exceptions, Edwards's photographs take "commerce" as their subject matter. They do so explicitly, through views of the port and levee. And they do so implicitly, through views of public and private edifices, across the city, built figuratively upon a foundation of sugar and cotton, banking and insurance. More difficult to fit into a context of commerce are two wonderful environmental portraits (pp. 91–92) that begin to put a human face on the city.

Steam power, a defining technology of the Industrial Revolution, serves Edwards as another principal subject. The scale of its use (the sheer size and cost of the equipment, the need for a full-time specialized mechanic to minister to the boiler, gauges, pipes and pistons) was suited to commercial operations, but had not yet made great inroads into personal, domestic life. Photographs of steamboats and steamships, railroad engines, and firefighting equipment marshal evidence—from all corners of the city—of the harnessing of this vaporous servant. Other images make their case through suggestion. Photographs of bales of cotton and hogsheads of sugar, massed along the levee, imply—even when they do not show—the presence of steam-powered cotton presses and sugar houses.

Nearly all of the Edwards photographs in this exhibition are related to images sold at auction in London in 1982. The Swiss consignor, when asked about the provenance of the photographs, said that his great-grandfather had collected them while traveling in America. Perhaps the selection reflects purposeful inquiry; perhaps the images simply appealed as souvenirs. Regardless, we must acknowledge this nineteenth-century "curator" whose taste in photography has shaped our understanding of J. D. Edwards.

Edwards's photographs, in round numbers, are now 150 years old. It is high time to take "a closer look" at the world they depict. To this end, each image is paired, in the galleries, with a complementary—or contrapuntal—item. In some cases, the exhibition curators have yielded to the temptation to contrast "then and now" views of the New Orleans cityscape. But in other cases, the content (or subtext) of the photographs suggests other, less obvious, comparisons. Each pairing functions as a portal into history—and reminds us of the open-ended narrative potential of photography. Gone, perhaps, is the sense of sheer wonder shared by photography's earliest audiences. But the photographs of J. D. Edwards still inspire us, as viewers, to see his world, and ours, anew.

—John H. Lawrence
Director of Museum Programs
The Historic New Orleans Collection

W HEN EDWARDS MADE THESE PHOTOGRAPHS
OF NEW ORLEANS ON THE EVE OF THE
CIVIL WAR, THE MEDIUM WAS A YOUTHFUL 20
YEARS OLD, HAVING BEEN INTRODUCED NEARLY
simultaneously in 1839 by Louis Jacques Mandé Daguerre in France
and William Henry Fox Talbot in England. Each of these processes
resulted in what we know as a photograph—though Daguerre's was
called a "daguerreotype" and Fox Talbot's a "photogenic drawing." The
two processes took radically different chemical approaches to making
pictures. In the end it was Fox Talbot's version that established the
model for photography for the next century and a half, using a negative
as a matrix from which to make identical positive copies.

By the late 1850s, photography had already undergone
transformations that its pioneers would have found unimaginable.
Improvements in lens design (to capture an image) and in chemistry
(to bring this "latent image" into view) resulted in shortened
exposure times. The invention of the stereoscope and its companion
the stereograph—both in use by 1851—presented viewers with
convincing facsimiles of a three-dimensional world. And the negative/
positive process was perfected by a host of experimenters—notably
Frederick Scott Archer, whose 1851 discovery of the wet collodion
process on glass plates facilitated the production of multiple prints
and revolutionized the process of making paper photographs. The
adoption of Archer's technique was widespread and rapid.

Edwards's photographs used the wet collodion process and could
theoretically be distributed in numbers as great as demand required.
In contrast, other photographic processes in use at the time—the
daguerreotype, ambrotype, and tintype—produced unique images
directly in the camera. The potential for reproduction and distribution
made glass-plate negatives attractive to photographers, who saw
the prospect of marketing their images to more people, in greater
quantities. But the creation of these negatives was arduous work.

The process began with the photographer's selecting a subject,
then composing and focusing the picture on a ground-glass screen of
a tripod-mounted camera. At this point the picture had in effect been
made, but not yet recorded.

The chemical components involved in the wet-plate collodion
process posed a variety of dangers: they were by turns flammable,

irritating, and narcotic, and had to be handled with care. Collodion is a nitrocellulose solution containing a salt—often potassium iodide—dissolved in alcohol and ether. When dry, collodion produces a tough film that adheres tightly to glass. To prepare a negative, the photographer carefully poured a puddle of syrupy collodion onto a glass plate. Tilting the plate from side to side encouraged the collodion to flow across the surface, providing more or less complete coverage. Photographers working outdoors, as Edwards often did, would enter a "dark tent," enclosed wagon, or other portable structure to treat the plate with a second solution, silver nitrate. The potassium iodide in the collodion reacted with the silver nitrate to produce light sensitive silver iodide. The plate, still wet, was then loaded into a lightproof holder and inserted into the camera. The plate in its holder aligned with the plane of focus of the ground-glass screen, ensuring that the image would be sharp.

The operation required delicate timing: the plate remained light sensitive only so long as the chemicals were damp. In quick sequence, the photographer pulled the slide to uncover the plate, opened the shutter (usually by uncapping the lens), and made the exposure for the number of seconds that conditions and experience dictated. The slide was then replaced and the holder removed from the camera. Retiring to the tent, the photographer developed, fixed, washed, and dried the plate—and evaluated the results. The creation of additional negatives demanded repetition of the entire sequence of steps.

Printmaking was an equally labor-intensive process. In the dark, a dried negative was placed in direct contact with a piece of light-sensitive paper, each component held in place by a special printing frame that applied pressure to keep the print and negative in intimate contact. Edwards probably used "salted paper," which was made photosensitive by coating first with a sodium chloride (salt) solution, then with silver nitrate to produce silver chloride. When exposed to sunlight, the negative "printed out" on the paper, without chemical development. The tonal range of the print resulted from variations in the negative's density—with darker, denser portions blocking more light than lighter, less dense areas.

Photographers could check on the progress of the development by lifting a corner of the paper from the frame. Once sufficiently exposed, the print was removed from the frame; treated (or "fixed") with chemicals to prevent further development from the action of light; and washed. Once dried, the print could be trimmed to final size and pasted to a mounting card for protection against creasing and tearing.

—John H. Lawrence

A NOTE ON DISTRIBUTION

IN THE DECADES PRIOR TO THE CIVIL WAR, AMERICANS BECAME INCREASINGLY DEPENDENT ON PRODUCTS MADE OUTSIDE THE HOME. THE ROSTER OF WIDELY AVAILABLE CONSUMER GOODS INCLUDED FOODSTUFFS, FURNISHINGS, dry goods, and—by the mid-1850s—photographic images. Advances in technology made the widespread distribution of paper photographic images possible. Curiosity about people and places, close and far removed, drove the craze for photographic images.

In New Orleans, J. D. Edwards' Gallery of Photographic Art advertised images

> *of New Orleans, the Bayous, Swamps and Shell Piles of Louisiana, Lowel [sic] Cotton Factories, Niagria [sic] Falls, Mount Vernon, Washington, Philadelphia, New York, Boston, Providence, R.I., Harvard College, Cambridge, Mass., New Hampshire, Montreal and Quebec, Canada, St. Louis, Mo., Constantinople, Turkey, Rome, etc., etc. for sale at the Gallery cheap.*

Edwards and his business partner, E. H. Newton Jr., could not fulfill every request with photos from their own studio. Instead, the partners relied on operators from across the country and around the world to supply their New Orleans clientele. The retailing of photographs created by another photographer or photographic firm was a common practice—often resting upon mutual agreement, but occasionally not. Certainly, some of Edwards's own photographs appear, with no credit, under the names of other photographers, but it is impossible to determine whether this was by arrangement or by "pirating."

Another avenue for the distribution of photographic images was a burgeoning popular press, increasingly attuned to the "news value" of visual elements. It took time—and money—to create a wood engraving from a sketch or photograph. If daily newspapers were relatively slow to adopt illustrations, periodicals such as the weekly *Frank Leslie's Illustrated Newspaper* (founded 1855) and *Harper's Weekly* (founded 1857) became celebrated for their visual content. Edwards

and Newton's work reached mass audiences when their prints were reproduced as wood engravings (see pp. 49 and 60) in *Leslie's* and the *New York Illustrated News.*

Work produced by Edwards prior to his 1862 departure from New Orleans was distributed under the names of at least two other photographers working contemporaneously in the city: Samuel T. Blessing and Louis Isaac Prince. Blessing, for one, advertised "photographs made either from Life, or copied from the Daguerreotypes of deceased persons…" in *Crescent City Business* in 1858–59. Whether the copying and retailing of Edwards's images was a consensual arrangement, or an opportunity seized, remains unknown. At least eight Edwards photographs were reissued as small *carte-de-visite* views (approximately 2½" by 4"). Several other images circulated by Blessing and Prince, though unattributed, are likely Edwards originals. These examples not only depict locations proximate to others photographed by Edwards, they also bear stylistic similarities to his work. Moreover, they appear to have been copied from prints, rather than photographed directly from life.

Marshall Dunham, a soldier with the New York 159th Regiment, compiled *carte-de-visite* prints in a souvenir album while stationed in New Orleans in July and August 1863 (see pp. 30, 33, 48, 56, 58, and 80). Dunham's regiment also saw action in other parts of Louisiana during the Civil War—and his album of some 200 images includes views of Baton Rouge, Donaldsonville, and Houma. Today, Dunham's album is housed in the Hill Memorial Library of Louisiana State University in Baton Rouge.

—John H. Lawrence

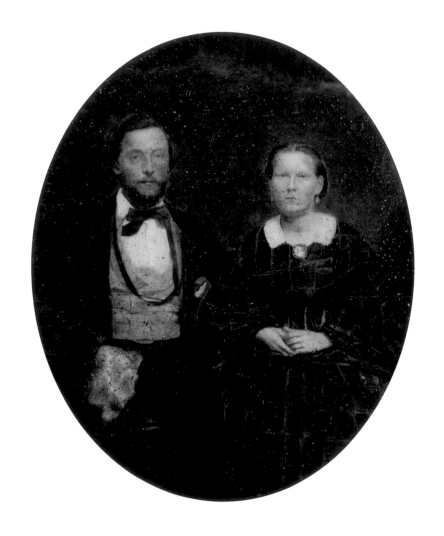

Jay D. and Mary Elizabeth Edwards
late 19th century; copy photograph
courtesy of Dr. Jay D. Edwards

J AY DEARBORN (MOODY) EDWARDS, A NEW ENGLAND NATIVE, ROSE TO BECOME ONE OF THE MOST IMPORTANT EARLY PHOTOGRAPHERS OF THE ANTEBELLUM SOUTH. BIOGRAPHICAL INFORMATION comes from both family oral history and documentary sources, but many details remain conjectural because no scholar has yet undertaken a comprehensive study of Edwards's somewhat complicated and peripatetic life. My father, Paul Marion Edwards, collected much of the available documentation of Edwards's life as part of a general family history that he wrote (but never completed) between 1995 and 1999. When my father died in Pittsburgh in 2002 at the age of ninety-nine, I inherited his research notes, family photographs, and photocopies of original documents and records.[1]

Though I bear the same name as my illustrious great-grandfather, and though I am only three generations removed from him, I learned little about my namesake during my youth in Pittsburgh. It was not until 1995, when my friend and LSU colleague Frank de Caro asked me if any relatives had spent time in New Orleans, that I learned of my family's local connection. Frank was doing research for a book on Louisiana photography and had come across mid-nineteenth-century photographs bearing my own rather uncommon name. Puzzled by Frank's discovery, I contacted my father, hoping he might be able to better explain the connection. The uncovering of Jay Dearborn Edwards's personal history became a family detective story; it was also the last project that I worked on with my father.

Little is known about Edwards's early years. Born Jay Dearborn Moody in Andover, New Hampshire, in 1831, he was the eldest of four children. The death of his father, Edwin Moody (1804–1842), left the family destitute—and prompted his mother, Mahala Sanborn

1 The author of this essay is related to Jay Dearborn (Moody) Edwards as follows: the photographer's third surviving son was William Moody Edwards, called Willy (1864–1940), who carried on J. D. Edwards's photographic business in Atlanta after his death. Willy's third son by his second wife, Margaret Terry, was Paul Marion Edwards (1903–2002). The only son of Paul Edwards and Marie Scanlon Edwards is Jay Dearborn Edwards (b. 1937), a professor of anthropology at Louisiana State University. A copy of the family genealogy is on file at The Historic New Orleans Collection's Williams Research Center.

Moody (1807–1874), to place Jay Dearborn in the care of an aunt and uncle who lived near Lowell, Massachusetts. He assumed the surname, Edwards, of his adoptive parents, while his siblings—Abigail, Matrasse, and Edwin—remained with their mother and retained the name Moody. Circa 1848 he left the Edwards household and traveled widely around the eastern United States, delivering lectures on phrenology.[2] In 1855, at the age of twenty-four, Edwards arrived in St. Louis and took up residence at the boarding house of a Mrs. Ogle. He fell in love with the landlady's daughter, Mary Elizabeth Ogle, and courted her for about a year. During their courtship, Edwards presented Mary Elizabeth with a "memory book," which has since been passed down through four generations of the Edwards family.[3] The couple married in St. Louis on September 30, 1856.

Jay Dearborn and Mary Elizabeth moved to New Orleans about 1857. They almost certainly traveled downriver by steamboat. It is not known where Edwards acquired technical knowledge of the new art of photography, but by 1858 he was already producing pictures. His first photographic studio may have been a wagon; unlike other New Orleans photographers of the time, he did a considerable amount of outdoor photography. By 1860, Edwards had established a photographic studio at 19 Royal Street, a two-story brick building between Canal Street and Custom House Street (now Iberville Street). He advertised the sale of inexpensive images depicting such geographically disparate locales as Rome and Constantinople, Canada and Niagara Falls, Mount Vernon, cities along the eastern seaboard, and the bayous and swamps of Louisiana.[4]

Photographs created between 1858 and 1861 by Edwards and his partner E. H. Newton Jr. are the earliest photographic images on paper of New Orleans. In 1861 Edwards received a commission to photograph the new Custom House, then nearing completion only two blocks from his studio, on Canal Street. Taking advantage of the Custom House's height—it was one of the tallest buildings in the city at the time—Edwards climbed to its roof and photographed the city and its waterfront.

After Louisiana seceded from the Union, the Confederate Army commissioned Edwards to travel to Pensacola with military units to photograph army camp life. While there he also took photos

2 Family oral history is the source for accounts of Edwards's travels.

3 A memory or "forget me not" book was a volume of essays and poetry written by loved ones to a friend or family member. A popular genre in the 1850s, blank albums were sold in most metropolitan areas. In the case of Mary Ogle Edwards's book, it was filled in over a number of years by her friends and relatives.

4 The exact start date of Edwards's photographic career is unknown, so we do not know how many of the photographs he offered for sale in 1860 were from his own cameras.

of fortified Confederate and Union positions, gunboats, barracks, a shipyard, and the lighthouse at Fort Barrancas.[5] When the Confederates abandoned Pensacola and the Union captured the house of Stephen R. Mallory, Confederate Secretary of the Navy, Union officials discovered several dozen of Edwards's photographs. The photographs uncovered in Mallory's Pensacola home indicted Edwards as a Confederate spy and soon forced his flight from New Orleans.

In the spring of 1862, with David Farragut's Union fleet fast approaching New Orleans, the Edwards family left Louisiana for Richmond, Virginia. Even though younger brother Edwin ("Eddie") Moody[6] was fighting for the North, Jay Dearborn's sympathies lay with the South. Rather than serve the Confederacy on the battlefield, Edwards acted as a courier, carrying mail for Lee's army between Petersburg and Richmond. While Edwards served in Virginia, Mary Elizabeth traveled by train to Massachusetts, where she bore the couple's second child, Charles, at the Moody family farm that July.[7] (According to family lore, she sewed gold coins in the hems of her skirts to carry the family fortune north for safekeeping.) In late 1862 or early 1863, Mary Elizabeth returned to Richmond with Edwards's mother, Mahala. Ironically, another family member also arrived in Richmond around this time. Eddie Moody was captured by the Confederates and incarcerated in Richmond's Libby Prison, where he died in 1864 without ever being permitted to see his family. Although Mahala Sanborn Moody spent the rest of her life in Virginia, she hated the South for this injustice.

Jay Dearborn and Mary Elizabeth remained with their children in Richmond until 1868. Edwards opened a china and glassware business in town, but by the time the couple's last daughter was born in 1870, the family had moved east to Princess Anne County on the coast, where they lived on a farm for about a decade. Scant documentary evidence from this period suggests that the family may have fallen on hard times, although Edwards's boys retained fond memories of hunting deer and wild pigs in the countryside around the farm. In March 1880, Edwards was appointed acting keeper of the old stone Cape Henry Lighthouse at the southern entrance of Chesapeake Bay. His eldest son (another Eddie) was appointed assistant keeper, while his third son, Willy, worked for

5 See Leslie D. Jensen, "Photographer of the Confederacy: J.D. Edwards," in *The Image of War: 1861–1865,* vol. 1, *Shadows of the Storm,* ed. William D. Davis (Garden City, NY: Doubleday, 1981), 344-47. Jensen speculates that Edwards's Pensacola-area photographs. some of which were reproduced in *Harper's Weekly,* "may have been a spur to another photographer, the nation's finest, Mathew B. Brady."
6 Edwin ("Eddie") Moody was born in 1840 and died in 1864.
7 Exactly how Mary Elizabeth was able to cross enemy lines several times in the midst of war is unknown, but it appears she did so with relative ease.

a contractor building the new, taller Cape Henry light, made from cast iron and steel. (Both lighthouses are still standing.) The cape was completely wild during those days, covered with dunes where the city of Virginia Beach stands today. Edwards was fired from his job in October 1885, ostensibly for padding the books. Politics may have been to blame: the county government had been taken over by the Democrats, and Edwards was an active Republican. While in Princess Anne County, Edwards took up photography once again, still using the difficult and temperature-sensitive collodion wet plate process. It was also in coastal Virginia that Edwards joined the Masonic Grand Lodge of Norfolk and became a Master Mason.

In 1886 the family moved again—this time to Atlanta, Georgia, where Edwards opened a photographic studio on Whitehall Street, near Five Points. The business was a family affair, with son Willy and son-in-law Lewis Karl Dorman (who had married daughter Rosa Bell in 1885) joining Edwards in the studio.[8] Lewis Karl and Rosa Bell divorced in 1889, but Willy remained actively involved in the studio, now called "Edwards and Son."

Edwards maintained his affiliation with the Masons during his Atlanta years, eventually advancing to the thirty-second degree, the highest possible degree in a Masonic order. Upon his death on June 6, 1900, he was one of the "best known Masons in the state."[9] The length of Edwards's funeral procession—over twelve city blocks—attests to his social prominence and large circle of friends.

Edwards's dedication to environmental, or outdoor, photography makes his artistic contributions unique for his time. Edwards captured the essence of place, whether in New Orleans or in Confederate army camps. Though the full extent of Edwards's contribution may never be fully understood—a large number of his photographs remain lost or unidentified—his pioneering photographic work remains one of the building blocks of nineteenth-century American photography.

—Jay Dearborn Edwards
Louisiana State University, Baton Rouge

8 A German immigrant, Dorman worked under Edwards as an assistant lighthouse keeper and telegrapher in Cape Henry. He married Rosa Bell Edwards (1870–1950) in 1884, when she was fourteen years old.
9 Obituary of Jay Dearborn Edwards, *Atlanta Constitution,* June 7, 1900.

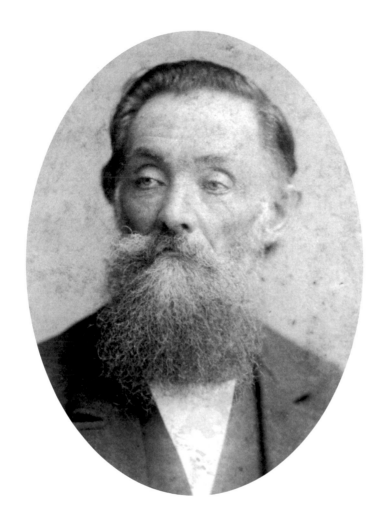

Jay Dearborn Edwards
late 19th century; copy photograph
courtesy of Dr. Jay D. Edwards

ON THE RIVERFRONT

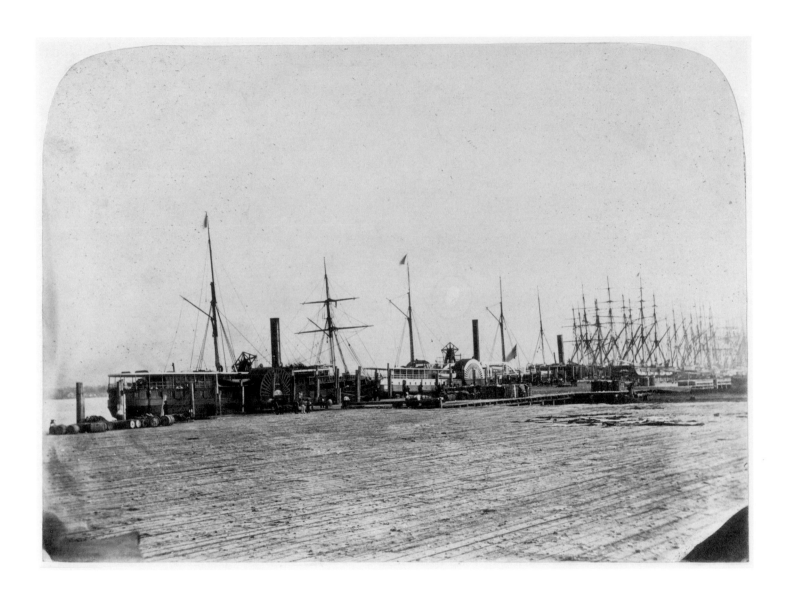

Levee Steamship Landing
between 1858 and 1861; salted paper photoprint*
Jay Dearborn Edwards, photographer
1982.32.17

*All salted paper photoprints in this exhibition by J. D. Edwards are mounted on board.

THE 1838 LAUNCH OF THE *GREAT WESTERN* FROM
BRISTOL, ENGLAND, SIGNALED THE BEGINNING
OF THE END OF THE AGE OF PURE SAIL. STEAM-
powered travel, once confined to inland waterways, had taken to
the open seas. Early oceangoing steamships maintained some sailing
capability: a sail provided stability and a backup system for the new
technology. At sea, when the necessity arose to fire a steam boiler,
coaling or wooding stations might not readily be available.

In 1859, sailing ships docking at New Orleans outnumbered
steamships by about five to one. (Steamboats outnumbered
steamships by more than ten to one.) Edwards's photograph
shows three steamships docked near Jackson Square, with the
more complex rigging of pure sailing vessels in the distance. The
steamship landing accommodated U.S. Mail ships as well as
those coming from the eastern seaboard, Europe, and Mexico and
Central America. At least one of the steamships (second from left)
has its foremast fitted with horizontal yards—an array of sails that
stabilized the vessel in heavy seas. Only fore and aft rigging is
visible on the other two, suggesting they plied the shallower and

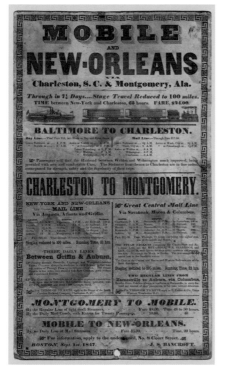

more sheltered waters of the coastal trade. As the
nineteenth century progressed, improvements in
the screw propeller, iron and steel construction,
and steam engine design allowed ships to shed
their sails entirely.

The planked surface of the levee at
this point along the riverbank represents an
upgrade in progress. Piers and earthen levees
(see pp. 32–33) were being replaced with wooden
decking. New Orleans at midcentury was a city
on the move. The marshalling of materials for
public works projects is evident in other Edwards
photographs (see p. 30). Getting from point A to
point B, within the city, had never been easier.
And, as an 1847 broadside makes clear, options
abounded for travel to points beyond.

Train and boat schedule
1847; broadside
J. S. Bancroft, publisher
86-2136-RL

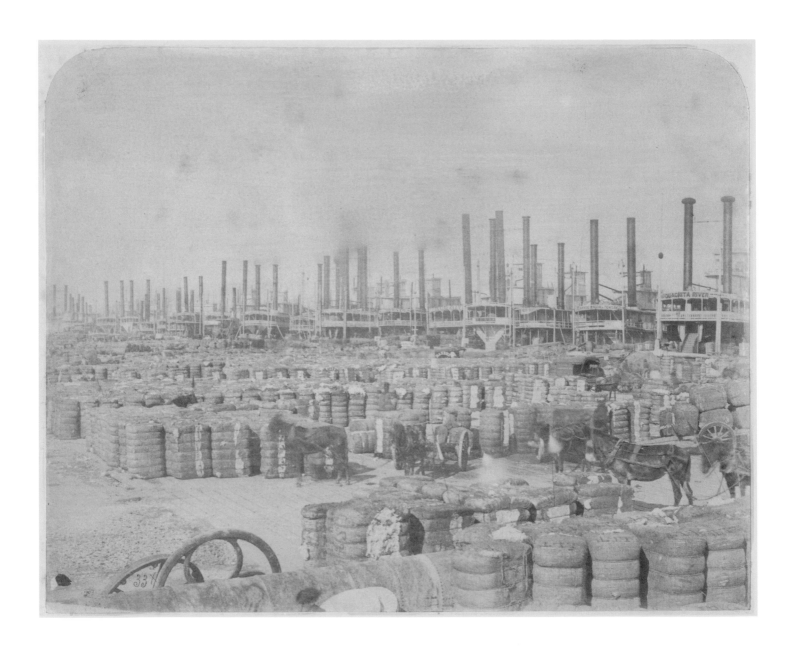

Loading Steamboats at New Orleans
ca. 1860; albumen print
Jay Dearborn Edwards, photographer
1985.238

IN ANTEBELLUM LOUISIANA, COTTON WAS HARVESTED FROM LATE SUMMER TO EARLY FALL; GINNED AND BALED NEAR THE GROWING SITE; AND SHIPPED VIA STEAMBOAT to one of New Orleans's large commercial presses, where it was further compacted for transport to the mills of New England or Great Britain. In 1860 New Orleans had twenty-one commercial cotton presses, with a combined capacity of some 2,250,000 bales.

The steamboats at the levee form a waterborne phalanx and bear signs of the routes they travel: Ouachita River, bayous Macon and Tensas, and Red River. These inland waters of northern and central Louisiana, all part of the Mississippi River drainage system, were the commercial corridors of the state's cotton-growing plantations.

In the foreground we see the riveted columnar form of what appears to be a steam boiler—perhaps an old one that has failed, perhaps a new one awaiting shipment to a sugar mill. A few light colored flags, planted in the bales closest to the camera, have been transformed into ghostly triangles by fluttering during the exposure. Such flags, along with stenciled markings on the bales, helped roustabouts identify particular groups of cargo to be handled. Amid the clutter of the bales on the wharf, drays pulled by mules are being loaded with cotton. A decade and a half later, once Mardi Gras parades were commonplace, many of these wagons served seasonal duty as the undercarriage for elaborate Carnival floats.

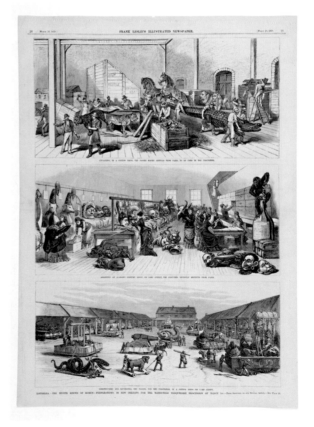

Constructing and Decorating the Floats …
in a Cotton Press on Camp Street
March 16, 1878; wood engraving
1980.38 i-iii

ON OCTOBER 20, 1859, UNDER THE HEADING "RIVER INTELLIGENCE," THE *NEW ORLEANS DAILY CRESCENT* NOTED THAT THE PACKET *MAGNOLIA* had arrived in port with 5,383 cotton bales on board, more than any boat had carried that season. A typical bale of cotton weighed between 400 and 500 pounds but—according to earlier reports in the *Daily Crescent*—some planters were shipping nearly 800-pound bales, trusting that steamboats and draymen would assume that "a bale is a bale" and charge by count rather than weight. Given the vast discrepancies in the size of individual bales, the *Magnolia* could have been carrying anywhere from two to four million pounds of cotton. What the *Daily Crescent* (and virtually every other New Orleans paper of the day) failed to comment on was the source of labor that picked this cotton: slaves.

Although the United States had abolished the international slave trade in 1808, the domestic trade flourished. As cotton cultivation moved south and west across a rapidly expanding United States, demand for slave labor followed suit. By the 1850s, New Orleans was home to the largest slave market in the Lower South (second nationally only to Charleston), supplying laborers to planters and traders throughout the lower Mississippi Valley and beyond. Figures from the 1860 census tell a statistical story but not a human one.

Abraham Lincoln issued the Emancipation Proclamation on January 1, 1863. The proclamation, though incomplete in its vision, embodied the resolve of the federal government to totally abolish slavery. The end of the Civil War and subsequent ratification of the 13th amendment to the United States Constitution, on December 6, 1865, ushered in universal emancipation and the complete abolition of the slave trade.

1860 CENSUS STATISTICS	
Louisiana total population:	**708,002**
Free white population:	376,276 (50.4%)
Total black population:	350,373 (49.6%)
Slave population:	331,726 (47%)
Free black population:	18,647 (2.6%)
New Orleans total population:	**168,675**
Free white population:	144,601 (85.6%)
Total black population:	24,074 (14.4%)
Slave population:	13,385 (8%)
Free black population:	10,689 (6.4%)

Proclamation of Emancipation by the President of the United States of America
1864, first issued January 1, 1863
Abraham Lincoln, author
97-351-RL

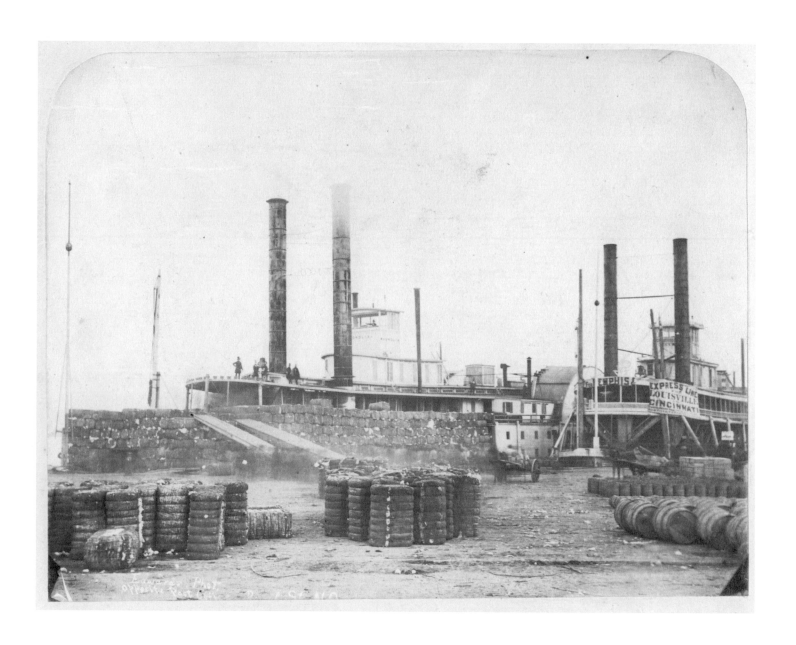

The Steamer Magnolia *at the Port of New Orleans*
between 1858 and 1861; salted paper photoprint
Jay Dearborn Edwards, photographer
1982.167.10

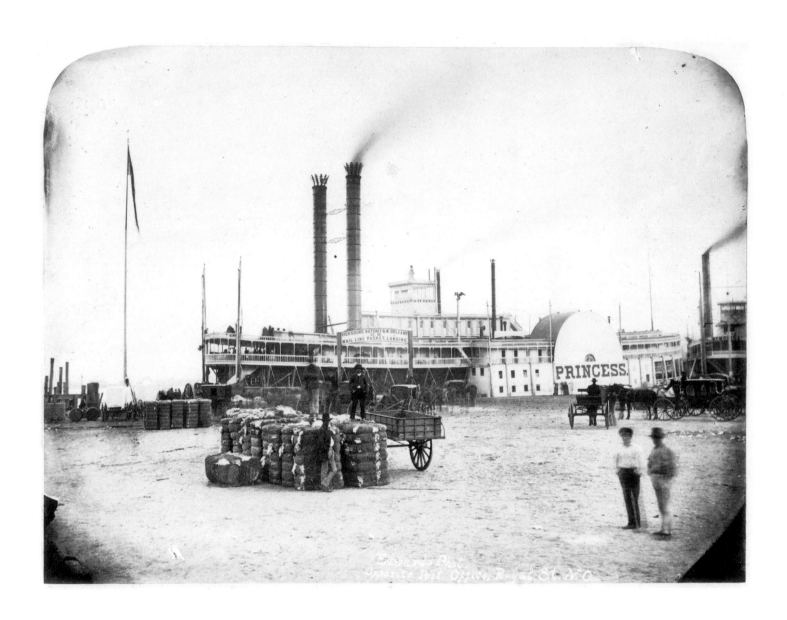

Steamer Princess
between 1858 and February 27, 1859; salted paper photoprint
Jay Dearborn Edwards, photographer
1982.32.1

IT IS WITH OBVIOUS PRIDE THAT THE MEN IN THIS PHOTOGRAPH POSE ATOP AND ALONGSIDE ENORMOUS COTTON BALES, TANGIBLE EVIDENCE OF THE ECONOMIC might of the port of New Orleans at midcentury. Positioned as they are, the men provide the viewer with a scale of reference: each cotton bale weighed between 400 and 800 pounds. The miniature bale seen below is a souvenir of the 1884–85 World's Industrial and Cotton Centennial Exposition.

The steamer *Princess*, built at Cincinnati in 1855, was a packet boat on the New Orleans to Vicksburg route. It is likely docked, here, near the foot of Canal Street or slightly upriver, at a landing reserved for steamboats. The light breeze present when this photograph was made, evidenced by the barely fluttering pennant and the plumes of smoke pushed aside from a purely vertical ascent, would not have deterred the *Princess*. Steam power enabled her to travel upstream or down, with or without wind.

Sailing ships, still a common sight along a Mississippi dotted with steamers, were moored further downriver at "finger piers"— wooden structures perpendicular to the bank that jutted out into the river and provided easy access for deeper-draft ships. Even as this photograph was made, finger piers were being replaced with a wide expanse of uninterrupted wharf.

Along with Edwards—and a statue of the steamer's namesake perched atop the pilothouse—we survey a scene both tranquil and prosperous. Neither the tranquility nor the prosperity would last. On February 27, 1859, the *Princess*'s boilers exploded as she traveled between Baton Rouge and New Orleans. Seventy people were killed. Barely two years later, the onset of the Civil War disrupted commercial activity across the region. In April 1862, with New Orleans on the verge of capture, Confederate officials ordered a vast quantity of cotton stored on the levee set afire to keep it from becoming the spoils of war.

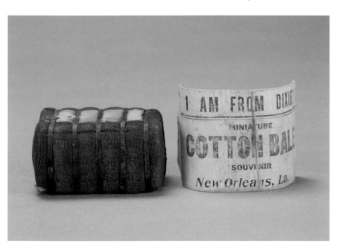

Miniature cotton bale
1884 or 1885; cotton, metal, and copper
2002.80.2 a,b
gift of Michael Patrykus and Sharon Robinson

THE FIRST STEAMBOAT TO ARRIVE IN THE CITY, THE APTLY NAMED *NEW ORLEANS,* TOOK EIGHTY-FIVE DAYS TO MAKE THE TRIP FROM PITTSBURGH IN 1812. In the following decades, steam-driven vessels would come to monopolize river transport. Although large skiffs still ferried passengers between New Orleans and the Westbank as late as the 1840s, steam ferry service had begun operation by 1827. As towns opposite New Orleans like Algiers, McDonoghville, and Gretna grew, ferry lines multiplied—and by the late 1850s there were four, one serving each of the city's districts.

The most prominent line was the Canal Street and Algiers Ferry, which steamed to Villere Street on the Westbank as often as four times an hour. While ferries served commuters, they also offered a popular diversion—especially during the summer, when riders took advantage of cooling river breezes. For just a single fare, passengers could travel back and forth, over and again, to their hearts' content. As captured in Edwards's photograph, the ferry terminal at the foot of Canal Street offered refreshments such as oysters, ham and eggs, and ice cream. In 1859 one ferryboat, the *Algerine,* created a sensation with its musical calliope, adding yet another attraction to ferry service.

By the 1880s the ferry building pictured here was replaced with a more substantial towered structure, itself replaced in the early twentieth century. In the 1920s yet another new terminal was built, with a passenger ramp along the first few blocks of Canal Street. A 1928 photograph by Charles L. Franck captures prospective passengers hustling to catch the ferry.

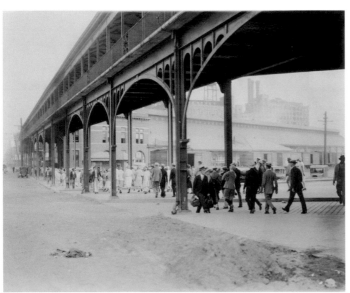

Album used to promote advertising for the New Orleans ferries
ca. 1928; photoprints mounted on linen in leather cover
Charles L. Franck Photographers, photographers
1981.67.1–.16

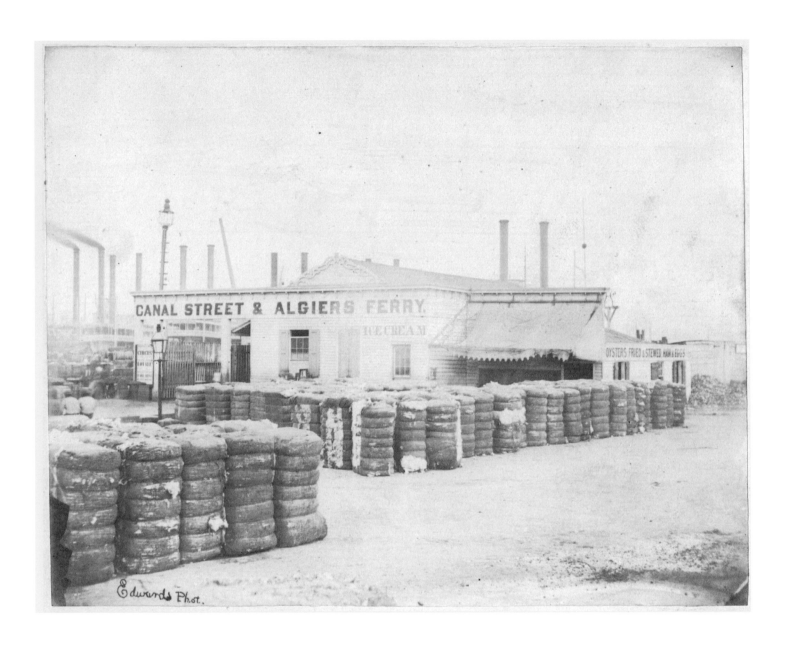

Canal Street and Algiers Ferry Building
between 1858 and 1861; salted paper photoprint
Jay Dearborn Edwards, photographer
1982.167.9

French Market
ca. 1864 from an 1858–61 original; albumen print
Jay Dearborn Edwards, photographer
Marshall Dunham Photograph Album, Mss. 3241
Louisiana and Lower Mississippi Valley Collections from the Louisiana State University Libraries in Baton Rouge

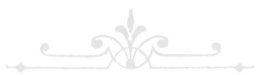

THE SCALE OF TRANSACTIONS MADE IN THE PUBLIC
MARKET JUST DOWNRIVER FROM JACKSON SQUARE
MAY NOT HAVE RIVALED THE HUGE SUMS HANDLED
in the buying and selling of sugar and cotton. Yet the markets served
as valuable indicators of the local economy. Initially, most were
located within a few blocks of the Mississippi River. As New Orleans
grew away from the river's high ground, markets followed, serving
virtually every district of the expanding city.

The rubric "French Market" describes a single facility though
not a single building. The complex consisted of separate meat and
produce halls (built in 1813 and 1822, respectively) flanking a fish
market (1840). Through the years ancillary structures, most notably
the Bazaar Market (1865), were added. Close by, but not part of the
municipal market, were the privately operated Red Stores, which
dealt in dry goods and sundries.

The riverbank adjacent to the French Market permitted the
delivery of local produce, seafood, and meat by boat. On market
days, vendors and buyers of varied ethnic and cultural backgrounds
crowded the stalls, reflecting the diversity of New Orleans and its
environs: French, Spanish, African, Native American, Irish, Italian,
and German. The latter group, first recruited between 1718 and 1721
by financier John
Law, became the
first produce farmers
in French colonial
Louisiana, settling
upriver in an area
still known as "the
German Coast."

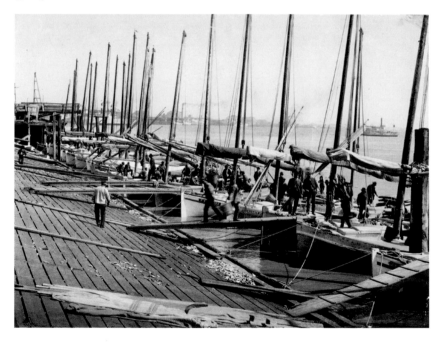

Oyster Smacks at the Levee, New Orleans
1900; color collotype
Detroit Photographic Co., photographers
1974.25.17.224

DURING THE 1850S THE PORT OF NEW ORLEANS WAS PRIMARILY OPEN LEVEE WITH UNCOVERED WHARVES AND PIERS, EVIDENT IN TWO PHOTOGRAPHS BY Edwards surveying the riverfront from atop the U. S. Custom House. Much of this land had recently been underwater, as shown in a circa 1810 map of the riverfront.

As it flows to the Gulf, the Mississippi River deposits sediment along its banks. The riparian zone is in constant flux, a phenomenon that played a role in the development of the New Orleans waterfront. In the eighteenth century, the river levee abutted present-day North Peters, Decatur, and Tchoupitoulas streets. By the early nineteenth century, constant siltation had built up the batture—the area between the levee and river channel—to the point that it could accommodate development. Several decades of litigation and a "war of pamphlets" over rightful ownership ensued, but the 1840s saw claims settled and development begun. By the 1850s the batture along the French Quarter was given over to port activity as far inland as North Peters; above Canal, commercial buildings reached all the way to Front Street. Further encroachment in the form of new streets, warehouses, and railroad tracks followed in the aftermath of the Civil War.

Steamboats cluster above Canal Street in Edwards's photographs, schooners below Jackson Square. Vessels were segregated by type along the wharves, required to dock in designated spaces. Large covered docks paralleling the river were not built until the early twentieth century—and these have since been replaced by tourist and recreational venues.

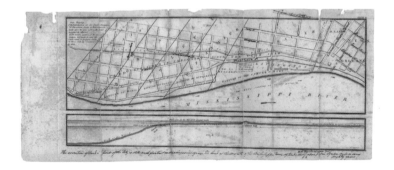

Plan Shewing 1st the Distribution of the Jesuits Plantation
ca. 1810; engraving
Henry Schenck Tanner, engraver
1981.226 i,ii

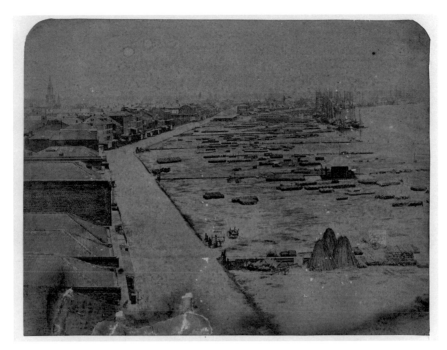

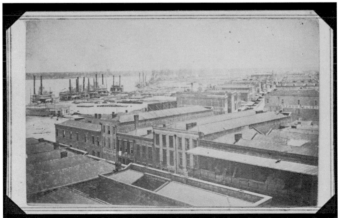

View of Decatur Street Riverfront and Lugger Landing from Roof of the Custom House
1860; albumen paper
Jay Dearborn Edwards, photographer
lent by the Louisiana State Museum

Front Levee from Top of Custom House
ca. 1864 from an 1858–61 original; albumen print
Jay Dearborn Edwards, photographer
Marshall Dunham Photograph Album, Mss. 3241, LLMVC-LSU

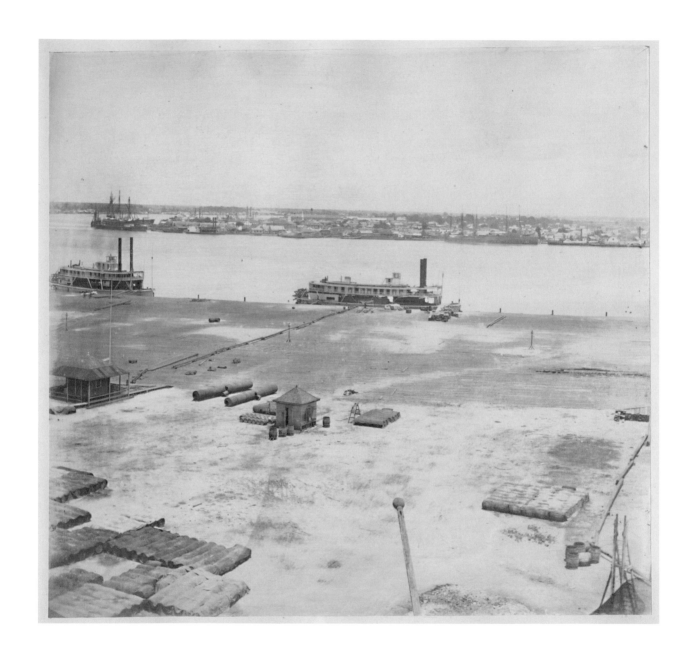

Steamers at the New Orleans Levee and Algiers
between 1858 and 1861; salted paper photoprint
Jay Dearborn Edwards, photographer
1982.167.3

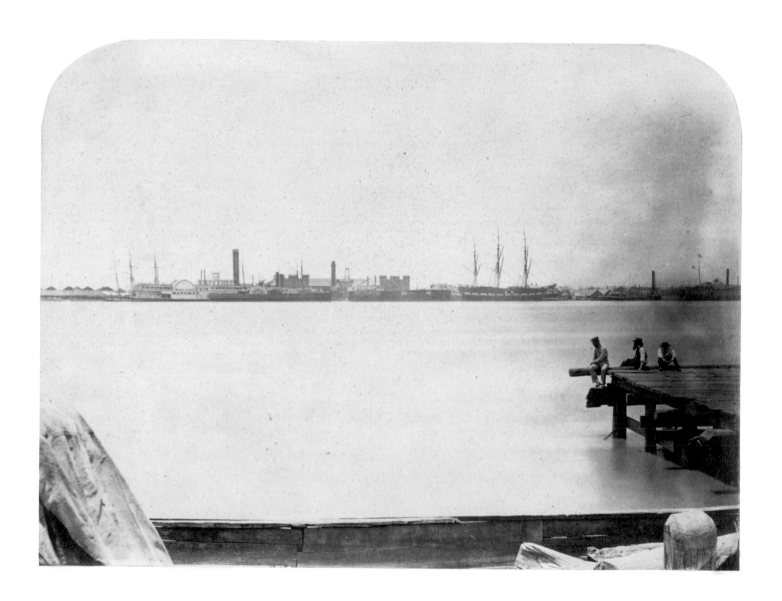

Algiers from Bywater
between 1858 and 1861; salted paper photoprint
Jay Dearborn Edwards, photographer
1982.32.16

THE STILLNESS IN THE PRECEDING PHOTOGRAPHS
IS AT ODDS WITH WHAT WE KNOW ABOUT THE PORT
OF NEW ORLEANS IN THE LATE 1850S: THAT ITS
levee was bustling with activity and jammed with cargoes of every
description. Part of this stillness derives from the photographic
process. Though the wet plate technique employed by Edwards
permitted relatively short exposures, most were long enough that
objects in motion—especially those occupying only a miniscule
portion of the picture's surface—would not register on the negative
or print. Even the Mississippi is tamed, presenting the glasslike
surface of a pond rather than the coursing vigor of the continent's
greatest waterway. Its ripples and eddies merged by a slow shutter
speed, the river assumes a placid appearance.

Edwards trains his lens on Algiers from two vantage points—
one, an unidentified elevated location, surely in the French Quarter;
the other, a spot at ground level, a little downstream from the first.
The prosperity of the port of New Orleans depended on the labors
performed at Algiers, where both sail- and steam-powered vessels
were kept in good working order. In addition to the Belleville Iron
Works—its castellated roofline visible in the second photograph—
Algiers housed dry docks and other ship-support facilities. Nearby
was the careening beach where wooden-hulled sailing ships were
occasionally beached for repairs or maintenance. In time, railheads
for western trains would be established in Algiers.

Although objects, not individuals, take center stage in these
photographs, the presence of local legends hovers. Thomas P.
Leathers was captain of the steamboat *Natchez*, which sits at berth in
the photograph on page 35, perhaps for maintenance. Many vessels
have borne the name *Natchez*; the one shown here was the fourth,
which operated from 1854 until 1860. The excursion steamer plying
the river today is the ninth. About a decade after these photographs
were taken, in 1870, Algiers was permanently annexed to the city
of New Orleans. Martin Behrman, born in New York City, but
raised from an infant in Algiers, served as mayor of New Orleans
from 1904 to 1920. Elected again in 1925, Behrman died only nine
months into his term.

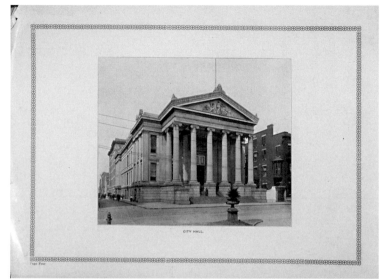

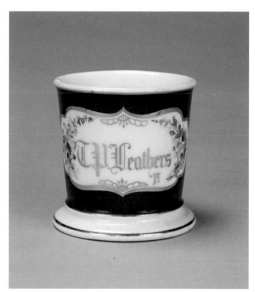

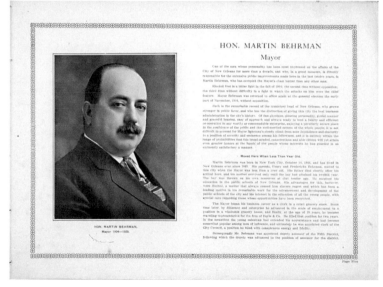

Shaving mug of Thomas P. Leathers, captain of the steamboat Natchez
between 1885 and 1900; china
H. & C., potter
1952.23

Cast of Thousands [Martin Behrman Administration Biography, 1904–1916]
edited by William M. Deacon; New Orleans: John J. Weihing Printing Co., 1917
96-258-RL

CANAL STREET AND BUSINESS DISTRICTS

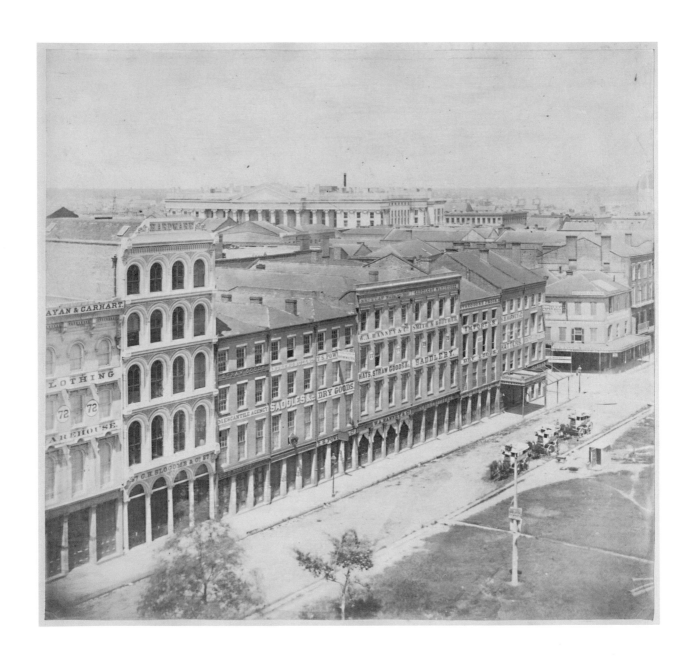

500 Block of Canal Street, South Side
1859; salted paper photoprint
Jay Dearborn Edwards, photographer
1982.167.1

Edwards took his camera high atop the United States Custom House, still under construction, to capture this view of Canal Street. To the left one catches a glimpse of the top of the St. Charles Hotel; just visible at the far right is the dome of the Jesuit Church of the Immaculate Conception on Baronne Street.

Today, the 500 block of Canal, between Magazine and Camp streets, is the site of a towering hotel. In the late 1850s, it was part of New Orleans's wholesale district. Prominent on several storefronts in Edwards's photograph are street numbers quite different from those now in use. An attempt at standardization was implemented in 1854, two years after the city's three municipalities merged (see p. 53). Buildings were to be consecutively numbered starting at either the Mississippi River or Canal Street, with odd and even numbers assigned to different sides of the street. But remnants of previous numbering systems stubbornly remained, as evidenced here with the numbers 72, 77, and 79 on the same side of the street.

The "new" address system was still in use in 1883 when E. Robinson and R. H. Pidgeon published the *Atlas of the City of New Orleans.* This detailed fire insurance atlas identified buildings by address as well as construction materials—pink for brick and yellow for wood. In 1894, New Orleans's current address system came into being. Each city block was assigned a discrete numerical designation in intervals of one hundred, with such designations running parallel from one street to the next.

Robinson map of business district
ca. 1883; lithograph with watercolor
E. Robinson, publisher
1952.8.3

I N THE COLONIAL PERIOD, THE FRENCH QUARTER WAS
SURROUNDED BY CITY COMMONS, OPEN LANDS THAT
CONTAINED PALISADES AND FORTIFICATIONS. AN 1810
decree subdivided the commons and included provision for a wide
navigation canal. Though the canal was never built, its planned
site became Canal Street. Edwards's panoramic view from atop the
U.S. Custom House clearly suggests the dimensions of the projected
waterway.

One of America's premier retail centers by the late 1850s,
Canal Street was the Crescent City's gathering place for political
rallies, demonstrations, and parades, its 171-foot width easily
accommodating crowds. In 1857 the first organized Carnival
organization, the Mistick Krewe of Comus, paraded on Mardi Gras
night. The krewe's initial route did not reach Canal Street, but large
and enthusiastic crowds in 1857 prompted a turn down the city's
main street the following year. Virtually every city Carnival parade
has followed suit since Comus's Canal Street debut.

The Comus parade was traditionally followed by a ball, held
for several years (beginning in 1872) at the Varieties Theatre next to
Christ Episcopal Church—its steeple visible to the right in Edwards's
photograph. During the parade, and at the ball, Comus carries a

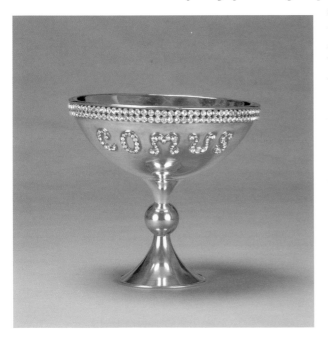

symbolic cup. Although the identity of
Comus is not publicly revealed, the cup
seen here belonged to General L. Kemper
Williams, the 1953 Comus, who with his
wife Leila established The Historic New
Orleans Collection. Since 1992, Comus
has chosen not to roll rather than accede
to a 1991 city ordinance requiring private
organizations parading on city streets to
offer membership to all races and genders.
Though a 1995 decision by the Fifth
Circuit Court of Appeals overturned the
city ordinance, Comus has yet to resume
its parade.

Comus cup
1953; silver plated with rhinestones
1953.8

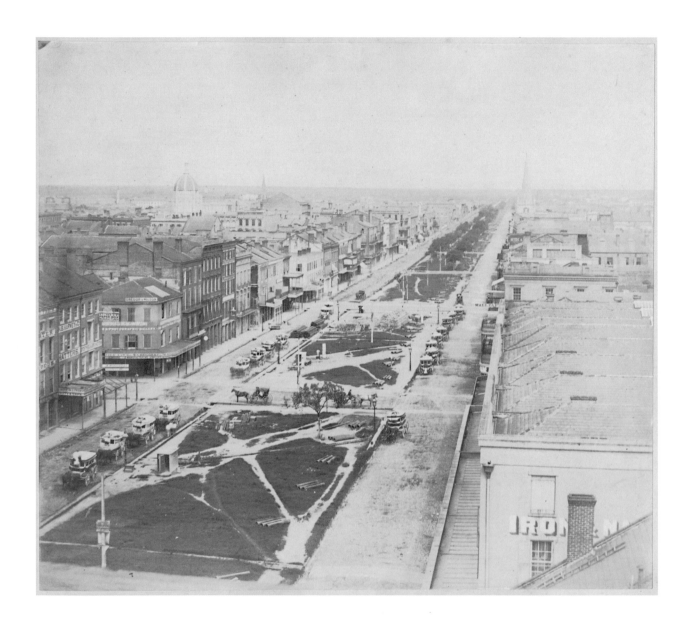

Canal Street from the Roof of the Custom House
1859; salted paper photoprint
Jay Dearborn Edwards, photographer
1982.167.2

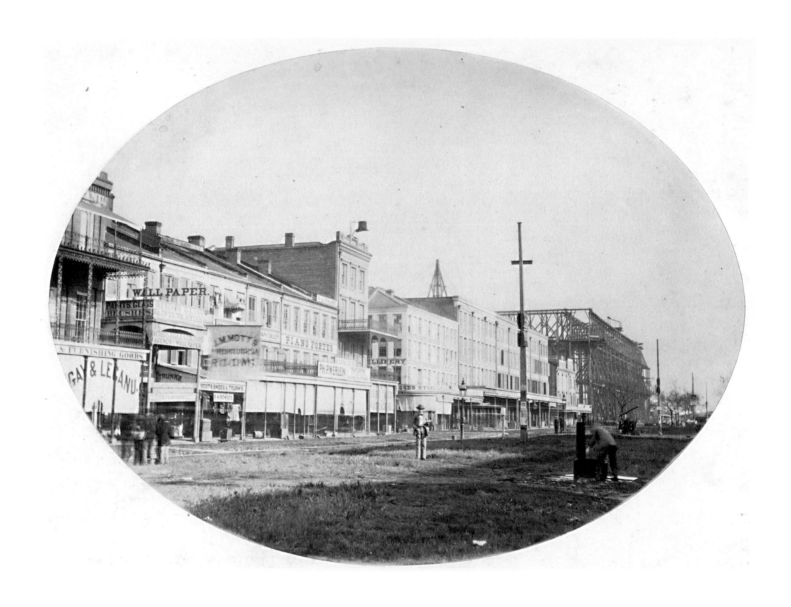

Canal Street from Chartres Street toward the River
between 1858 and 1859; salted paper photoprint
Jay Dearborn Edwards, photographer
1982.32.2

WHEN EDWARDS TOOK THIS PHOTOGRAPH LOOKING FROM CHARTRES STREET TOWARD THE MISSISSIPPI RIVER, CANAL STREET WAS STILL UNPAVED AND the U.S. Custom House—the large building in the distance surrounded by scaffolding—had been under construction for over a decade. The Custom House ranked among the largest and most impressive American government buildings in the United States and represented the financial power generated by the port of New Orleans.

The fifth largest city in the nation, New Orleans was by far the largest city in the South—and for many people its very name was synonymous with the region as a whole. Local legend ascribes the origins of the term "Dixie" to a New Orleans-issued banknote. The Citizens' Bank, located in the French Quarter, printed its notes in both English and French. On the reverse of the $10 bill was the word *dix*—French for ten. Before long the bilingual banknotes, dubbed "Dixies" by visitors, had generated a new nickname for New Orleans. By the late 1850s, "Dixie" or "Dixieland" had come to refer to the entire South.

In 1859 Daniel Emmett, a native of Mt. Vernon, Ohio, wrote "I Wish I Was in Dixie," soon to become the unofficial anthem of the Confederacy. The song's New Orleans publisher, Werlein's Music Store, appears near the center of Edwards's photograph. Construction on the Custom House, meanwhile, was complete through the level of the roof when the war began in 1861—but the building's cast-iron cornice would not be added until after Reconstruction, some two decades later.

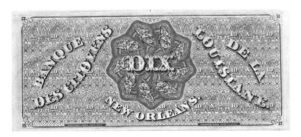

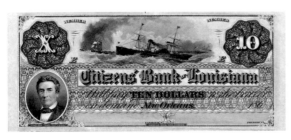

Citizens' Bank of Louisiana "Ten-Dix" bank notes
patented April 23, 1860; paper currency
National Bank Note Company, printer
1974.15.13

ALTHOUGH TREES HAD BEEN PLANTED ALONG CANAL STREET'S MEDIAN AS PART OF A BEAUTIFICATION EFFORT IN THE 1830S, THE STREET REMAINED poorly maintained into the 1850s. Little effort was expended on permanent alterations—such as paving—as long as plans persisted to dig a navigation canal along the route. This scheme was finally abandoned in the early 1850s, coincident with the street's transformation from primarily residential to commercial in character. When wealthy businessman Judah Touro died in 1854 he left money to upgrade Canal Street—and for a year after his death the street was named Touro Boulevard in his honor, before officially reverting back to the more popular Canal Street in 1855.

Major improvements began in 1859 with the installation of large square-cut stones in the roadway. In addition, flagstone sidewalks were re-laid; and wide, granite-lined gutters were built along the sidewalks and median, the latter lined with cast-iron bollards. Paved streets remained a rarity in antebellum New Orleans. Surfacing materials ranged from shells to planks, cobbles to cut stone. Though some of the heavier paving stone was imported from northern quarries, salvaged stone ballast from ships ascending the Mississippi River was also used. Canal Street's stone pavements were torn up in 1898–99 and replaced with asphalt.

The street's tallest building, Christ Episcopal Church (built 1847, demolished 1883), may be seen to the right in Edwards's photograph, on the corner of Dauphine Street. The Maison Blanche department store occupied the site from 1897 to 1998, when it was converted to an upscale hotel.

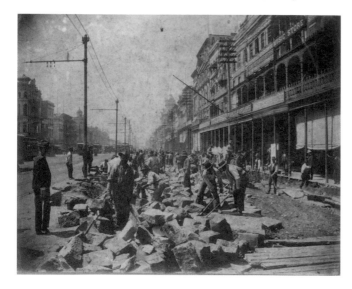

Canal Street Paving
December 27, 1898; photoprint
Ernest Pierre Carriere, photographer
1981.324.7.1
gift of Allan Phillip Jaffe

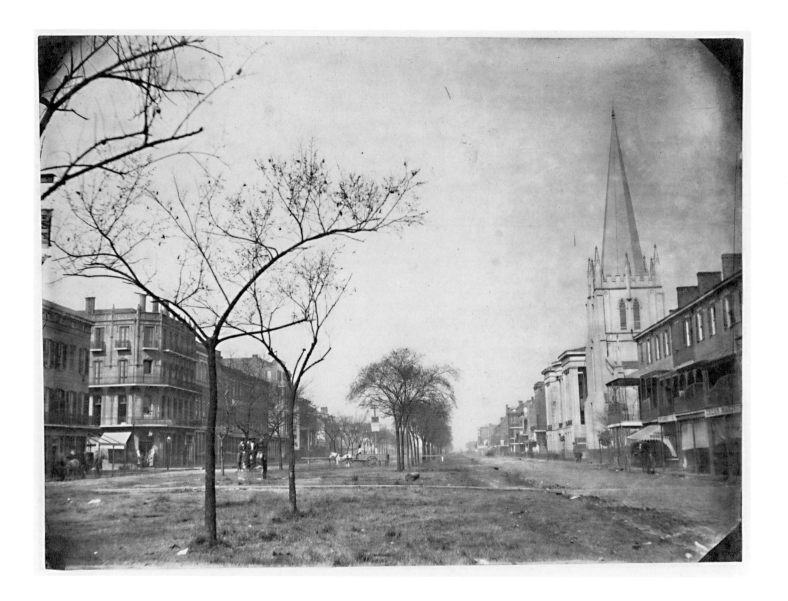

View of Canal Street, from Bourbon, Looking toward the Lake
between 1858 and 1859; salted paper photoprint
Jay Dearborn Edwards, photographer
1982.32.15

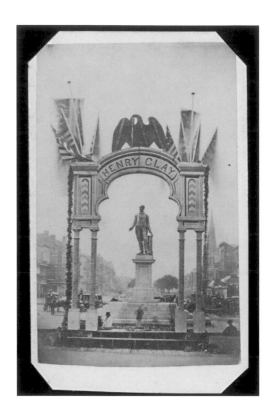

Henry Clay Statue, Canal Street
ca. 1864 from an April 1860 original; albumen print
Jay Dearborn Edwards, photographer; Samuel T. Blessing, photographic printmaker
Marshall Dunham Photograph Album, Mss. 3241, LLMVC-LSU

IN THE SPRING OF 1860, THE *NEW YORK ILLUSTRATED NEWS* PUBLISHED A WOOD ENGRAVING OF THE NEW HENRY CLAY MONUMENT, DEDICATED IN NEW ORLEANS in April that same year. Unlike many engravings based on photographs, which sacrificed content for the sake of narrative simplicity, this view was rich in detail. A caption in the *News* identified the source as a photograph by "Mr. Edwards, of New Orleans." Widely disseminated and frequently reproduced, Edwards's photographs were not always fully credited. The *carte-de-visite* pictured here, surely an Edwards original, may have been issued by Samuel T. Blessing, a local photographer.

Affection for the "Great Compromiser" ran deep in New Orleans. Upon Clay's death in 1852, a local monument committee was tasked with creating a fitting tribute. Dedicated on April 12, 1860, on what would have been Clay's eighty-third birthday, the monument stood in the middle of Canal Street at its juncture with Royal and St. Charles. The site was soon a favorite gathering spot for public activities both sanctioned and spontaneous. But as the Canal "neutral ground" filled with streetcar tracks and switches, the monument's huge stepped base posed an obstacle. In 1895, the base was reduced as an accommodation to rail traffic— a solution that ultimately proved inadequate. In 1901 the figure and its pedestal, along with the reduced base, were moved several blocks away to the center of Lafayette Square (see pp.52–53), where they remain today.

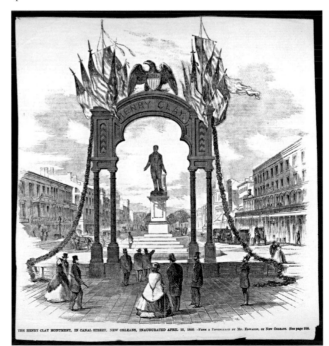

THE HENRY CLAY MONUMENT, IN CANAL STREET, NEW ORLEANS, INAUGURATED APRIL 12, 1860.—FROM A PHOTOGRAPH BY MR. EDWARDS, OF NEW ORLEANS. (See page 356.)

The Henry Clay Monument, in Canal Street
published April or May 1860 in *New York Illustrated News;*
wood engraving from a photoprint by Jay Dearborn Edwards
1993.101

I T IS LITTLE WONDER THAT EDWARDS PHOTOGRAPHED THE ST. CHARLES HOTEL. IT WAS AMONG THE MOST PROMINENT BUILDINGS IN NEW ORLEANS AS WELL AS one of the world's grandest hotels. Situated in what is now the 200 block of St. Charles Avenue, the hotel helped establish the American sector as New Orleans's town center. The hotel's public spaces and sprawling restaurant were popular gathering places—especially on Christmas and Mardi Gras, when costumed revelers could be spied in abundance. Note the cast-iron galleries on the adjacent buildings. In Edwards's day, such galleries were common throughout the city; today they are associated almost exclusively with the French Quarter.

The first incarnation of the St. Charles opened in 1836 and was crowned by a dome, measuring forty-six feet in diameter, visible for miles up and down the Mississippi River. In 1851 the hotel was consumed in a spectacular fire but was soon rebuilt. This second structure, photographed by Edwards, had no dome due to structural concerns. (Even before the fire, the building exhibited signs of sinking due to the weight of the dome.) In most other respects, however, the new hotel was modeled on the old, echoing its columned, Greek revival splendor.

In 1893 the second St. Charles, too, was lost to fire, and this time the replacement bore no resemblance to its predecessors. Rising seven stories from the sidewalk—with later annexes reaching twelve stories—the third St. Charles typified a new style of "skyscraper." One of the city's *grandes dames*, the St. Charles became part of the Sheraton hotel chain in the late 1950s and was renamed the Sheraton-Charles. By 1974, having seen better days, the hotel was finally demolished. One surviving artifact is the copper lion's head displayed here. For many years a parking lot occupied the old St. Charles site until towering Place St. Charles was built in the mid-1980s.

Lion's head from the St. Charles Hotel cornice
created for 1894; pressed copper
2001.103
gift of Vic Kirkpatrick

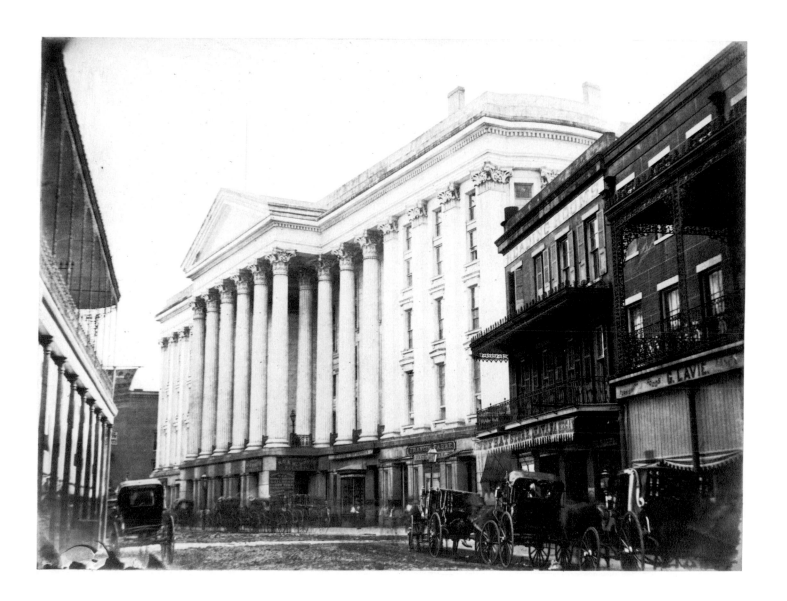

St. Charles Hotel
between 1858 and 1861; salted paper photoprint
Jay Dearborn Edwards, photographer
1982.32.10

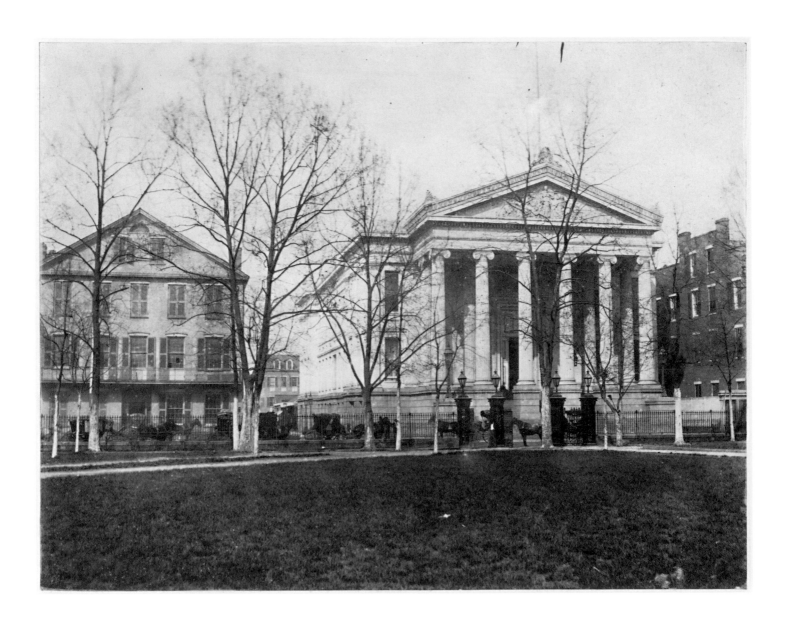

City Hall and Police Station
between 1858 and 1861; salted paper photoprint
Jay Dearborn Edwards, photographer
1982.167.7

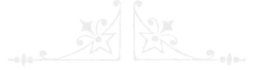

From 1836 to 1852, New Orleans operated under three distinct governments, or municipalities. As seen in Norman's 1845 plan, the First Municipality, bastion of the city's Creole community, included the original core of New Orleans, the Vieux Carré. The Second Municipality extended upriver from the city's first suburb, St. Mary (or Ste-Marie), established 1788. The Third Municipality extended downriver from the Vieux Carré, incorporating the Faubourg Marigny (established 1806) and many smaller subdivisions until reaching the St. Bernard Parish line.

An ordinance of 1852 consolidated New Orleans under a single government. Edwards's photograph shows the building (completed in 1850) envisioned as the seat of government for the Second Municipality but repurposed as the unified city hall. Commonly referred to as Gallier Hall—after its architect, James Gallier Sr.—the building epitomizes Greek revival style with its temple-like form. It faces Lafayette Square, a public square originally called Place Gravier but renamed for the French military hero following his 1825 visit to the city. Gallier Hall remained New Orleans's seat of government for over a century, until the current city hall was dedicated a few blocks away in 1957.

The consolidation of city offices into the area known as "the American Sector" signaled the end of public dominance long exerted by French-speaking Creoles, whose role in politics and economics had been unshakeable even after New Orleans became an American city in 1803. Migration of Americans from eastern and trans-Appalachian states, along with immigrants from Europe, produced numerically superior constituencies and cultural blocs that ended Creole hegemony.

Norman's Plan of New Orleans & Environs, 1845
1845; wood engraving with watercolor
Henry B. Moellhausen, civil engineer
Benjamin Moore Norman, publisher
1949.7 a,b

WHEN GIROD STREET IN THE FAUBOURG STE-MARIE WAS LAID OUT FOLLOWING THE GREAT FIRE OF 1788, IT STOOD WITHIN A FEW HUNDRED FEET of the city's upriver limits. Though the suburb was created at the zenith of Spanish influence in New Orleans, many of its major streets reference French Creole figures: Nicolas Girod, Julien Poydras, and Jean Gravier, from whose plantation tract the subdivision was formed. Following the Louisiana Purchase, the area became the quarter preferred by "Americans."

Edwards's view of Girod between Carondelet and St. Charles shows three buildings—a militia unit and two firefighting companies—that exemplify the call to public service. The heavily rusticated façade of the Washington Artillery headquarters (third from right) is unapologetically fortress-like, its martial air enhanced by relief cannon balls and (a crowning touch) finials resembling cannon barrels. When photographed by Edwards, the building was spanking new, having been completed in 1858 from a design by architect William Freret. Its tenant organization, formally established in 1838 and still active to this day, has seen service in military conflicts dating to the Mexican War.

Next to the artillery hall are the American Fire Company (Nº 2) and the Columbia Fire Company (Nº 5), with a ladder truck and steam engine (both hand-pulled) on view in the street. At the time Edwards photographed the block, these two were among the twenty-five active volunteer companies in New Orleans.

Lieutenant Colonel J. B. Richardson's
Washington Artillery Plaque
created for May 15, 1885; silver plate
1957.77
gift of Harold Schilke

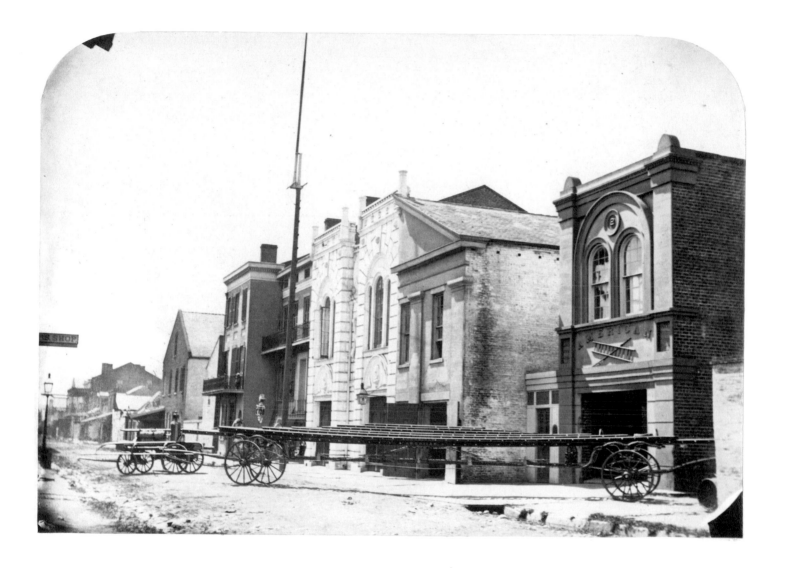

Girod Street between Carondelet and St. Charles
between 1858 and 1861; salted paper photoprint
Jay Dearborn Edwards, photographer
1982.167.12

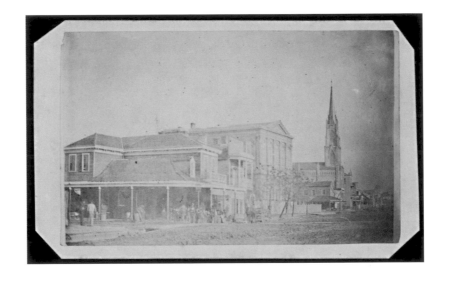

View on Common Street, Opposite Charity Hospital
ca. 1864 from an 1858–61 original; albumen print
Jay Dearborn Edwards, photographer
Marshall Dunham Photograph Album, Mss. 3241, LLMVC-LSU

HERE EDWARDS LOOKS DOWN COMMON STREET (NOW TULANE AVENUE) FROM SOUTH ROBERTSON TOWARD THE DOME OF THE JESUIT CHURCH OF the Immaculate Conception, visible to the right in the distance. More prominent is the Gothic-style spire of St. Joseph's Church. Built in 1852, St. Joseph's served a congregation formed largely of European immigrants. By 1892, however, St. Joseph's congregation had outgrown the building and moved to a new structure a few blocks away. Renamed St. Katherine's, the old church served African American Catholics from 1895 until the 1960s, when structural concerns forced its closure.

Among the people posing in front of the business at the corner of South Robertson might be some students and staff from nearby Charity Hospital, just across Common. Because of Charity's teaching capacity, this neighborhood has long been associated with the city's medical schools. One of these was the New Orleans School of Medicine, located in the large building with arched windows, which opened in 1856 under the guidance of Dr. Erasmus Darwin Fenner. A pioneer in clinical education, the school was also the first in the United States to initiate bedside teaching. It closed its doors in 1870; was reorganized as Charity Hospital Medical College in 1874; and closed for good in 1877. The building was razed around 1886 to make room for the Charity Hospital Ambulance House, itself replaced in 1927 by the hospital's interns' residence.

Medical education has advanced tremendously since the heyday of the New Orleans School of Medicine. That said, some of the implements (retractors, scissors, clamps) found on this 1968 award presented to Dr. Alton Ochsner—medical luminary and namesake of New Orleans's largest hospital system—would have been familiar to Dr. Fenner in the 1850s.

Panel of Medical Equipment
created for April 20, 1968
83-40-L.1
gift of Jane Kellogg Ochsner, Dr. E. W. Alton Ochsner Jr., Dr. John Lockwood Ochsner,
Isabelle Ochsner Mann, Mims Gage Ochsner

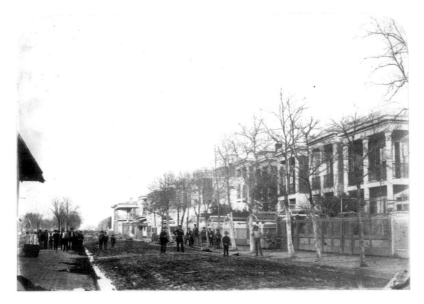

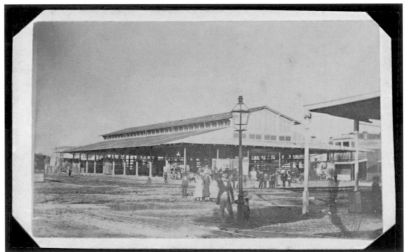

South Claiborne Avenue at Common Street
between 1858 and 1861; salted paper photoprint
Jay Dearborn Edwards, photographer
1982.32.13

Claiborne Market
ca. 1864 from an 1858–61 original; albumen print
Jay Dearborn Edwards, photographer; Louis Isaac Prince, photographic printmaker
Marshall Dunham Photograph Album, Mss. 3241, LLMVC-LSU

T HESE VIEWS—ONE OF SOUTH CLAIBORNE AVENUE, THE OTHER OF THE CLAIBORNE MARKET—ARE TWO OF EDWARDS'S MORE POPULATED PHOTOGRAPHS. Indeed, crisply rendered crowd scenes are relatively rare in mid-nineteenth-century photography. Due to the long exposures required, moving objects such as horses, carts, and people generally became invisible or blurred into "ghosts." In order to provide an image with both clarity and scale, photographers often asked individuals to stand still for the duration of the exposure.

In Edwards's time, Claiborne Avenue still lay on the outskirts of the city, but the area was enjoying rapid development. Miles of live oak trees—a celebrated neighborhood feature for more than a century—were planted along the avenue in the 1840s and '50s. The public market was new as well, established at the corner of Claiborne and Common in 1855. As Edwards points his camera along Claiborne toward Canal, from a location near the market, a row of houses in the then-popular abstracted Greek revival style is visible through the bare wintry trees. The matching house facades, raised picket fences, and pergola-like structures extending back from the sidewalk provide a look of tidy newness.

The middle decades of the twentieth century would see the erasure of the neighborhood's verdant character. The Claiborne Market was demolished by 1939, one of dozens of public markets to fold in the face of competition from larger privately operated grocery stores. The construction of the modern Charity Hospital complex and expansion of the Central Business District transformed once-residential blocks into commercial space. And in the late 1960s, the neighborhood suffered its most ignominious loss: the beloved live oaks were razed to make way for the elevated I-10 expressway. The human presence along Claiborne Avenue—captured so painstakingly by J. D. Edwards—must have remained, in a sense, invisible to those planning the interstate.

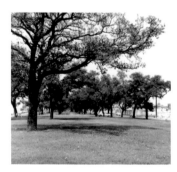

Claiborne Downtown from Canal
1967; photograph
William Russell, photographer
92-48-L.22

Claiborne and Dumaine toward Downtown
1967; photograph
William Russell, photographer
92-48-L.23

I T IS NO EXAGGERATION TO SAY THAT EVERY VESTIGE OF WHAT THIS PHOTOGRAPH SHOWS HAS TODAY BEEN OBLITERATED. THE LARGE BALES OF COTTON—WEIGHING several hundred pounds each—were possibly awaiting further compression at Freret's Cotton Press. But cotton is no longer a principal product passing through the port of New Orleans, and the modest buildings stretching along Poydras Street have been replaced with office towers, grand hotels, and the massive Superdome. One constant linking past to present, however, is the spirit of commerce, evident in this photograph and present today in Poydras's legal and financial institutions and offices devoted to oil and gas exploration.

By making multiple prints of a single image, mid-nineteenth-century photographers could play a limited role as "publishers." But some images (like the one below, attributed to Edwards's partner, E. H. Newton Jr.) were disseminated even more widely through their conversion to wood engravings and their publication in periodicals. The conversion process generally simplified the content and structure of the image, and a descriptive caption enhanced the informational value.

Small press runs of illustrated books, sales catalogues, and advertising materials incorporating actual photographic illustrations were produced from the 1850s through the 1880s. Photographically derived printed images (photogravures and Woodburytypes) were also used to enhance published texts, particularly those focused on the visual arts. The photographic relief halftone, not in wide use until the 1890s, heralded the rise of photographically illustrated publications in the twentieth century.

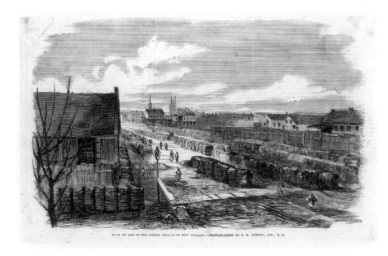

View of One of the Cotton Presses in New Orleans
published April 21, 1860 in *Frank Leslie's Illustrated Newspaper;* wood engraving
from a photograph by E. H. Newton Jr.
1959.159.6
gift of Boyd Cruise and Harold Schilke

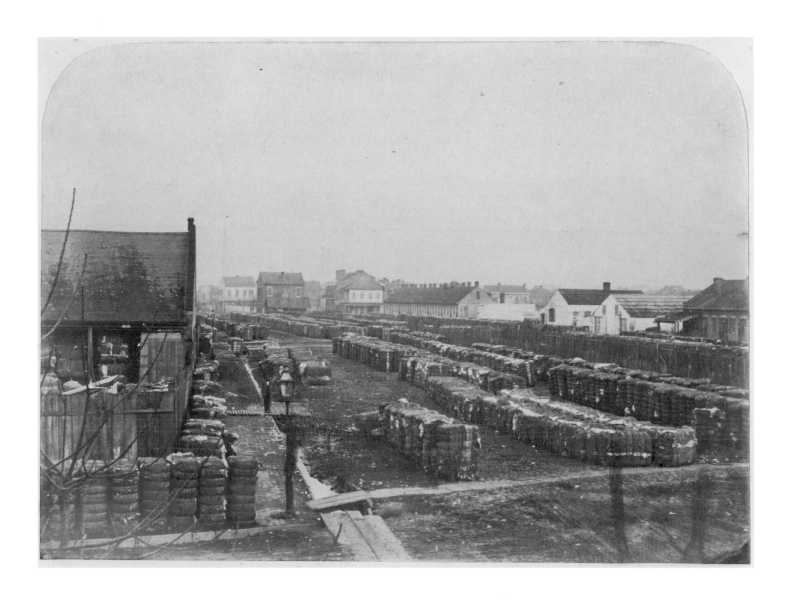

Freret's Cotton Press, Poydras Street
between 1858 and 1860; salted paper photoprint
Jay Dearborn Edwards and E. H. Newton Jr., photographers
1982.32.7

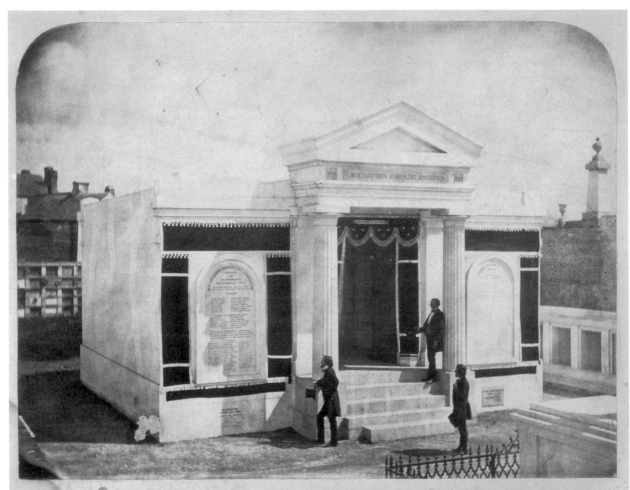

VIEW OF THE TOMB OF THE NEW LUSITANOS BENEVOLENT ASSOCIATION,
ERECTED IN GIROD STREET CEMETERY, NEW-ORLEANS, A. D. 1859.

(Photographed at J. D. Edwards' Gallery of Photographic Art.)

View of the Tomb of the New Lusitanos Benevolent Association
1859; salted paper photoprint
Jay Dearborn Edwards, photographer
1974.25.6.624

Throughout its history New Orleans has been home to hundreds of private social organizations. Although the best known today are the Mardi Gras "krewes," the first of these, Comus, was not formed until 1857. More common in the mid-nineteenth century were philanthropic organizations defined by shared vocation, religion, or cultural heritage. Among many of these groups, membership dues helped cover the cost of burial in a common tomb.

The New Lusitanos Benevolent Association, a Portuguese group, celebrated its first anniversary on Sunday, October 23, 1859. Following an elaborate marching parade through today's French Quarter and Central Business District—with numerous stops and activities planned along the way—the group convened in the Girod Street (or Protestant) Cemetery to dedicate the society's tomb. Edwards's photograph of the crape-festooned edifice, with some members posing still as statues in front, may date to the anniversary itself.

A French émigré, Jacques-Nicolas Bussière de Pouilly, designed the tomb. (Despite the look of stone in Edwards's photograph, the construction was primarily plastered brick.) By the mid-twentieth century the cemetery had fallen into disuse, its vaults and mausoleums in disrepair. Photographs by Clarence John Laughlin, Guy Bernard, and others capture a pitiful yet picturesque state. In the late 1950s human remains at the Girod Street Cemetery were relocated to the newly created Hope Mausoleum near the lake end of Canal Street. In 1962 the cemetery grounds were given over to a federal government complex, helping establish adjacent Loyola Avenue as the city's major administrative corridor.

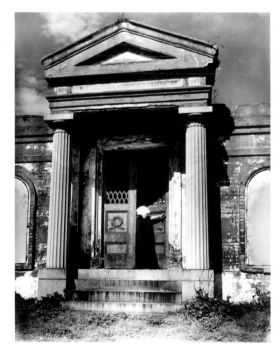

The Dead Command, Number Two
March 30, 1940; photoprint
Clarence John Laughlin, photographer
1981.247.1.731

V IEWED FROM ABOVE, A MAP OF NEW ORLEANS
BEARS LITTLE RESEMBLANCE TO A RECTILINEAR
GRID. MANY STREETS RADIATE, LIKE SPOKES ON A
bicycle wheel, from a more-or-less central hub to the sinuous Mississippi
River. Where "spokes" converge, city blocks assume a triangular shape.
The wedge bounded by Felicity and Polymnia streets has long been a
major commercial district, part of today's Central City neighborhood.
But in the late 1850s, when Edwards took this view of Felicity looking
toward the Mississippi, the area was primarily residential. Scattered
businesses were starting to grow up along the portion of nearby Dryades
Street now called Oretha Castle Haley Boulevard.

The neighborhood is low-lying, situated more than a mile from
the higher ground of the river's natural levee. Before construction
of a citywide drainage system in the early twentieth century, heavy
rains frequently caused flooding. Edwards's photograph shows the
deep, wide gutters that channeled rainwater to the nearby Claiborne
drainage canal (not yet an extension of South Claiborne Avenue).
The dirt streets and valley-like gutters were difficult to navigate
under most circumstances and required numerous small bridges to
facilitate crossing.

Today Central City is a predominantly African American
neighborhood—though at the time this photograph was taken,
and for decades following, the area was home to a large Irish and

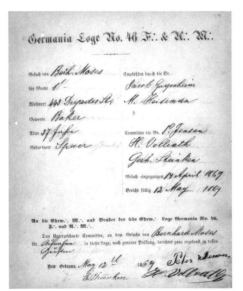

German immigrant population. Among the entries in a
book listing individuals who petitioned for membership
in the Germania Lodge, a freemason chapter composed
exclusively of German-speaking members, is "Berh.
Moses," a baker identified as a Dryades Street resident
in 1869. Although Moses's religion is not specified, it
is tempting to speculate that he belonged to the Jewish
community, largely German in origin, that was starting
to populate the neighborhood. By the first half of the
twentieth century, Jewish-owned stores lined Dryades
Street—and a number of synagogues still stand in the
vicinity, some now adapted to other uses.

Petition book from the Germania Lodge, Nº 46
1869-1919
Germania Lodge Nº 46, Inc.
courtesy of Germania Lodge Nº 46, Inc.

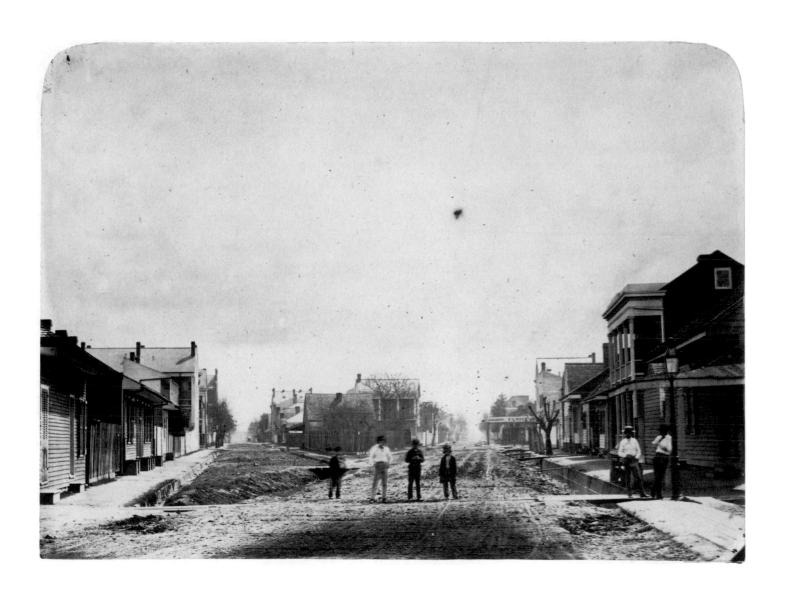

Intersection of Felicity and Polymnia Streets
between 1858 and 1861; salted paper photoprint
Jay Dearborn Edwards, photographer
1982.32.14

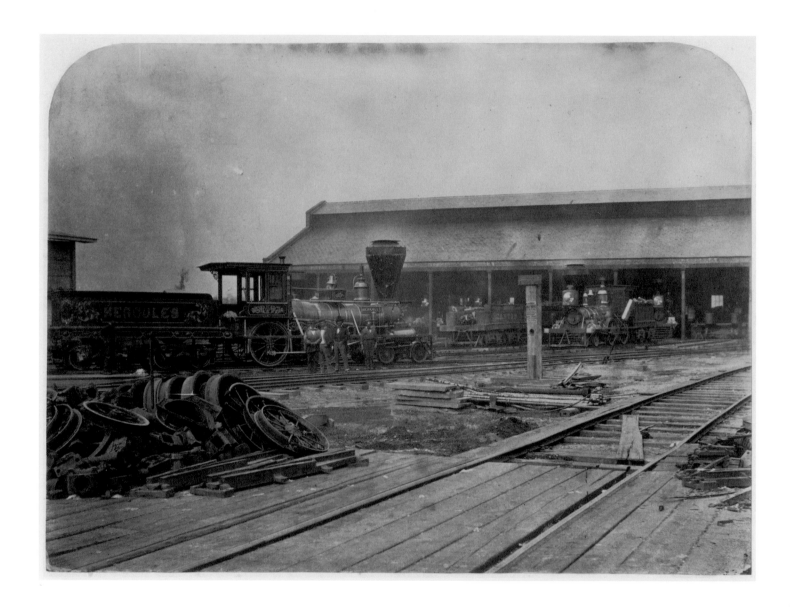

Jackson Railroad Yard
between 1858 and 1861; salted paper photoprint
Jay Dearborn Edwards, photographer
1982.32.6

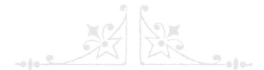

WHEN THIS PHOTOGRAPH WAS TAKEN, THE NEW ORLEANS, JACKSON AND GREAT NORTHERN RAILROAD WAS THE ONLY INTERSTATE LINE operating out of New Orleans. Completed in 1858, the line extended to Jackson, Mississippi, a distance of approximately 200 miles. The railroad property was bounded by South Claiborne, Locust (Magnolia), Clio, and Calliope on land abutting today's Pontchartrain Expressway (Interstate 10).

Through the 1850s, even as railroads proliferated across the nation, New Orleans remained strongly dependent upon the Mississippi River for interstate as well as international shipping. As domestic trade became increasingly rail-based, its orientation shifting from north-south to east-west, the Crescent City's complacency hindered its ability to compete with emerging trade centers like St. Louis, Chicago, and even tiny Atlanta. One proposal, never implemented, called for a transcontinental railroad connecting New Orleans and San Diego. Instead, the first cross-country line, completed in 1869, passed farther to the north, linking Omaha to Sacramento via the Union Pacific and Central Pacific railroads.

In the decades following the Civil War, the pace of railroad expansion picked up in New Orleans, with new connections to the north and east. In 1880, the old NOJ&GNRR line became part of the Illinois Central, stretching a combined 1,700 miles from New Orleans to Sioux City before reaching its Chicago terminus. In 1881, a merger of the Southern Pacific with several Louisiana and Texas lines finally linked New Orleans to the west coast, at Los Angeles. By 1889, as seen on a Southern Pacific route map, the Crescent City was accessible by rail to nearly the entire nation.

Map of the Southern Pacific Railway
& Steamship Lines
October 1889; color lithograph
Poole Bros., printer
1977.302 i-vi

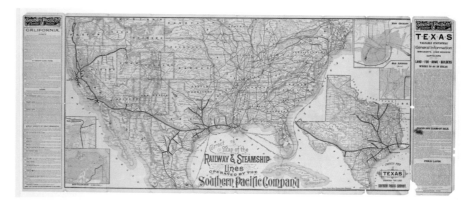

THE NEW ORLEANS THAT J. D. EDWARDS KNEW WAS NOT A CITY OF LARGE URBAN PARKS. CALLS FOR THE CREATION OF A PUBLIC PARK NEAR LAKE Pontchartrain began in 1851 but City Park—as the space came to be called—remained largely unimproved until the 1890s.

In the 1850s, city dwellers seeking fresh air could visit public squares like Jackson, Washington, Lafayette, or Coliseum Place. Or they could promenade on Esplanade Street—seen here from Royal Street, looking toward the lake. Although Esplanade was not a true park, its tree-lined median functioned as a shady retreat. Locals came to stroll—and to settle, too. As the Quarter grew more crowded and less desirable, aristocratic townhouses grew up along Esplanade. By the 1850s the avenue extended all the way to Bayou St. John, as emphasized in a penciled caption on the photograph's mount: "2 rows of trees 2 miles long."

Before it was an avenue, Esplanade was part of the city commons that surrounded the French Quarter until 1810. Today Esplanade serves as a designated boundary between the Quarter and Faubourg Marigny. But as evidenced by this copy of an 1807 plan showing property ownership, Esplanade was not part of the original 1806 subdivision of the Marigny plantation, which began a short distance from the lower boundary of the commons.

Plan du Faubourg Marigny
1870s from an 1807 original; ink with watercolor
Barthélémy Lafon, surveyor; Claude Jules Allou d'Hémécourt, draftsman
1966.34.5

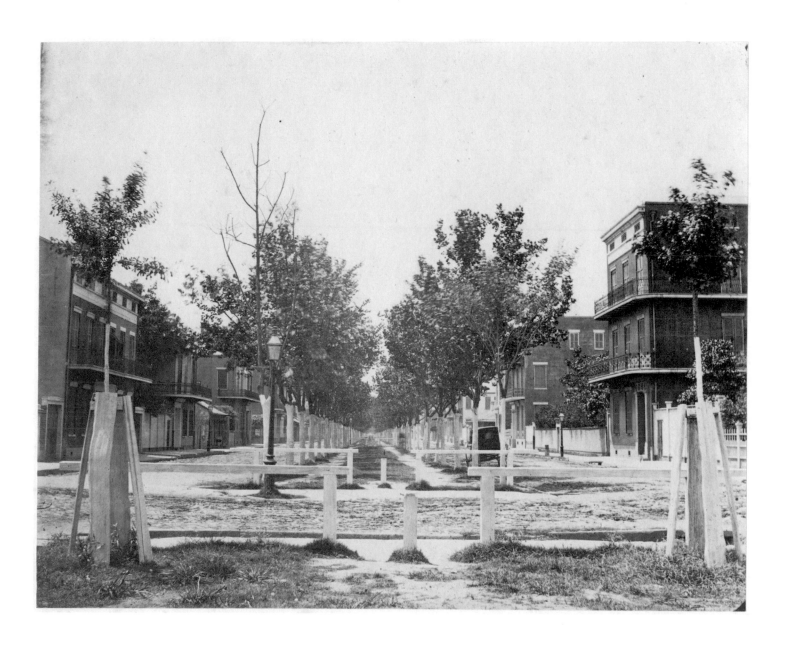

Esplanade Street from Royal Street toward Lake
between 1858 and 1861; salted paper photoprint
Jay Dearborn Edwards, photographer
1982.167.5

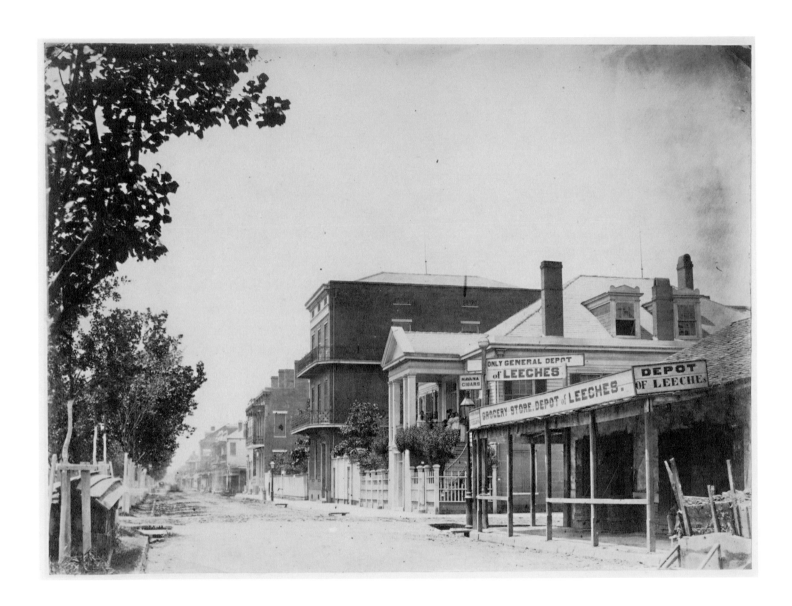

J. B. Soubiran Grocery Store, Downriver Side of Esplanade Street
between 1858 and 1861; salted paper photoprint
Jay Dearborn Edwards, photographer
1982.167.11

EVEN ALONG THE FINEST NEW ORLEANS STREETS—
LIKE ESPLANADE, SEEN HERE AT ITS INTERSECTION
WITH ROYAL—NEIGHBORHOOD CORNER BUSINESSES
were fixtures. With its wooden overhang to protect shoppers from
sun and rain and its curbside hitching rail for horses, this particular
grocery resembled other corner stores across the Crescent City. Its
signage indicates that it sold not only groceries but also Havana
cigars. It must have had a line of apothecary goods, too, since it
stocked leeches.

For over two thousand years these blood-sucking wormlike
water-dwellers have been used for medical purposes. Leeching—
like bleeding—was regarded as a general cure-all and a respected
treatment for cleansing feverish humors by lowering the patient's
body temperature. Modern medicine eventually came to regard
such "heroic" treatments with scorn. But in an ironic turnabout, the
hirudin in the saliva of leeches is now used as an anticoagulant and
blood-clot breaker in state-of-the-art microsurgery.

In the nineteenth century medicinal leeches—*hirudo
medicinalis*—were imported from Europe and stored by pharmacists
or physicians in tall, elegant glass or porcelain jars. Some jars
were covered with muslin; others had matching glass or porcelain

perforated lids allowing the leeches to
breathe. Fresh water and, on occasion,
a spot of moss created a sustainable
environment. No special foods were
required, since a leech would satiate
itself on a patient's blood before being
returned to its jar for future use.

Leech jar
mid-19th century; ceramic
lent by the Louisiana State Museum

W HEN EDWARDS PHOTOGRAPHED THE THIRD
DISTRICT (OR PORT) MARKET AT THE FOOT OF
ELYSIAN FIELDS AVENUE, IT WAS ONE OF TWELVE
public markets operating in New Orleans. By the early twentieth
century the number of markets had surpassed thirty, among the
largest totals for any city in the United States. Today, although
several neighborhoods host weekly or bi-weekly markets, the French
Market is the Crescent City's only remaining permanent public
market structure.

Built in 1840, the Third District Market served the Faubourg
Marigny. Markets typically served as neighborhood anchors: once
a market was established, other businesses were quick to follow.
Evidence of a flourishing business district is visible along New Levee
Street (today's North Peters) in the background of this photograph.

Aside from its array of public markets, New Orleans also
supported a thriving community of street vendors, who operated on
foot or by cart throughout the city. Colorful cries announced the
nature of their wares. The intricately molded wax figure pictured
here, a Mexican flower vendor, is the work of the family of Francisco
Vargas. Members of the Vargas
family traveled to New Orleans from
their native Mexico in 1884–85 to
exhibit wax creations at the World's
Industrial and Cotton Centennial
Exposition. The family remained in
New Orleans—and, for more than a
century to follow, made a successful
business creating and selling wax
figures, many depicting the city's
African American street vendors.

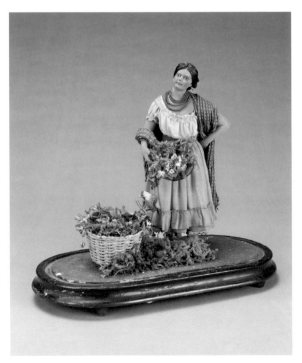

Mexican woman selling flowers
between 1879 and 1890; wax and cloth
Francisco Vargas Sr., Concepcion Vargas Alfonso,
and Adeline Vargas Mastio, sculptors
1969.16

Third District Market
between 1858 and 1861; salted paper photoprint
Jay Dearborn Edwards, photographer
1982.167.8

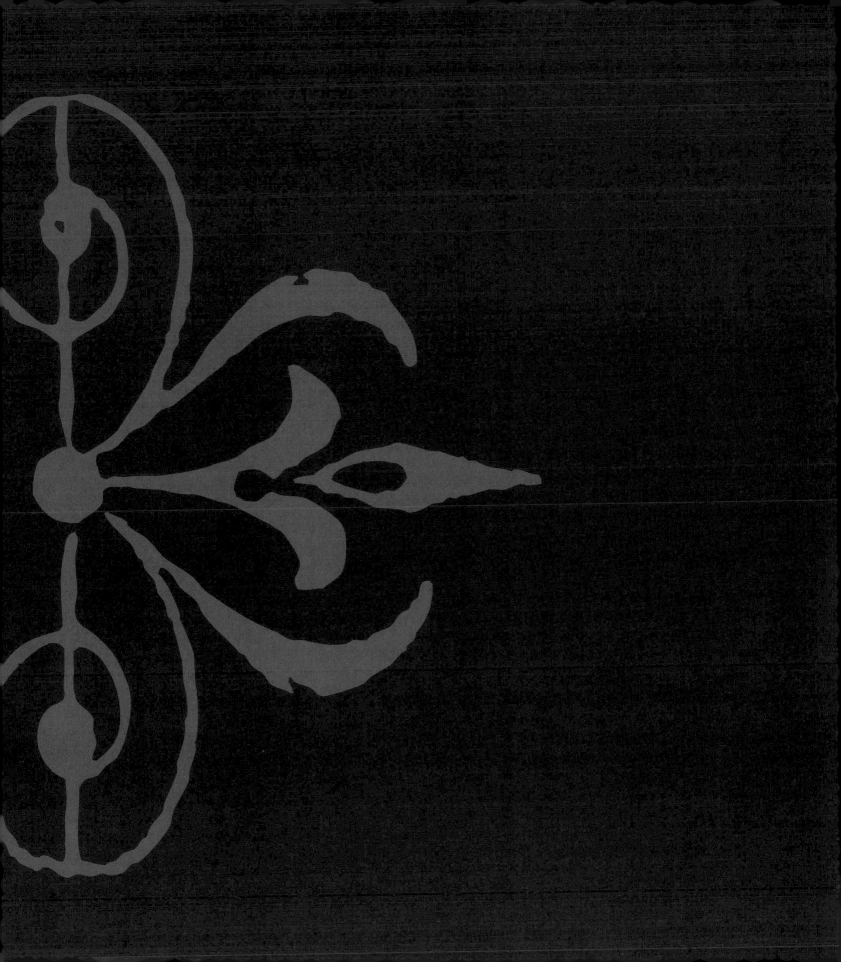

HOMES AND GARDENS

BOSTONIAN THOMAS A. ADAMS MADE A FORTUNE IN 1840S NEW ORLEANS AS A PIONEER IN THE CITY'S MUTUAL INSURANCE BUSINESS. IN 1848–49 HE built this large frame house at the corner of Prytania and Fourth streets, in what was then the suburb of Lafayette. In 1852 Lafayette was annexed by New Orleans as the Fourth District.

The fastest growing section of New Orleans in the 1850s, the Fourth District contained some of the nation's showiest residential streets. Large lots and abundant greenery presented a stark contrast to the closely built French Quarter and recalled the more exclusive neighborhoods of northeastern cities. The term "Garden District" originally applied to all of the finer, tree-lined, Uptown streets—not just the small New Orleans neighborhood recognized by that name today. The sobriquet was current (and popular) enough by 1863 to be the title of a waltz.

When Edwards photographed the Garden District in the late 1850s, wooden fences of pickets or boards were still common, but lacy cast-iron fences were gaining in popularity. The wooden fence visible to the right—just across Fourth Street from the Adams residence—would be replaced, in 1859, by one of the most famous cast-iron enclosures in New Orleans. The celebrated "cornstalk fence," purchased from an ironworks catalogue, lent additional grandeur to the villa of Col. Robert Henry Short. While the Adams House burned to the ground in the late 1930s, Colonel Short's villa and fence are still standing. Two other, smaller cornstalk fences may be found in New Orleans—one on Royal Street in the French Quarter, another on North White Street just off Esplanade Avenue.

"Garden District Waltz"
1863; sheet music
Charles Young, composer
F. W. Bremer, publisher
86-1147-RL

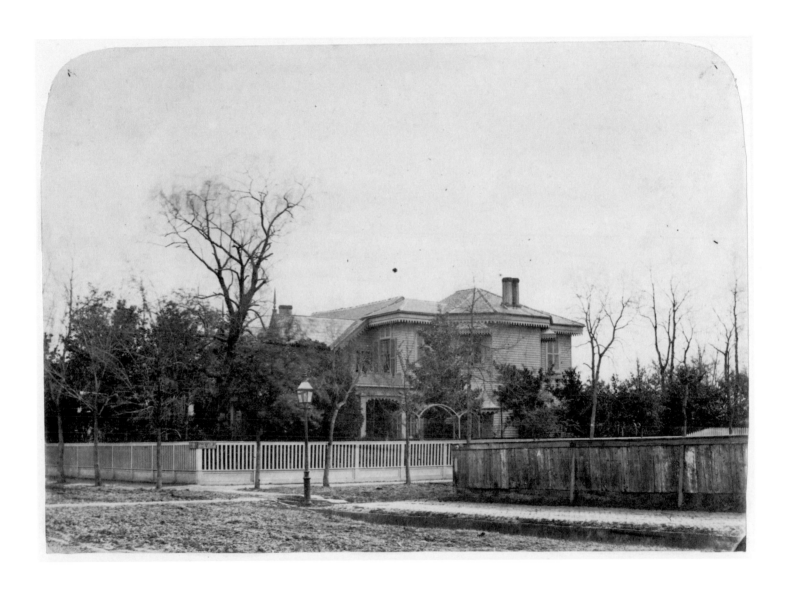

Thomas A. Adams Residence
between 1858 and 1861; salted paper photoprint
Jay Dearborn Edwards, photographer
1982.32.8

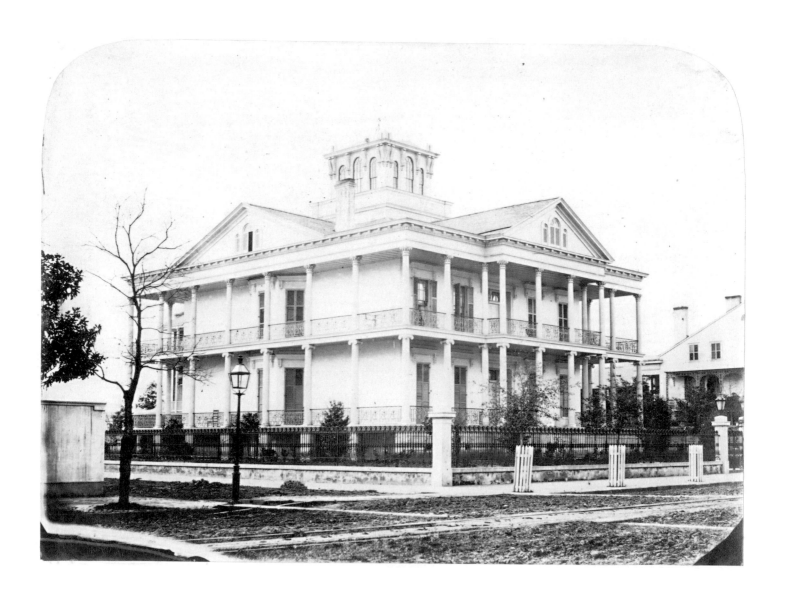

Henry Buckner Residence
between 1858 and 1861; salted paper photoprint
Jay Dearborn Edwards, photographer
1982.32.5

ONE OF THE GARDEN DISTRICT'S MOST PALATIAL MANSIONS WAS ERECTED IN 1857 AT THE CORNER OF JACKSON AND COLISEUM STREETS. THE ORIGINAL owner, Henry Sullivan Buckner, built a fortune through cotton trading and other entrepreneurial ventures in booming antebellum New Orleans. His house remains standing today, minus its belvedere but surrounded by its original cast-iron fence.

For more than sixty years after its construction, the Buckner House served exclusively as a private residence. Then, in 1923, it became home to Soulé College, a local educational institution with a storied history. Established in 1856 by George Soulé, the college boasted that it was the largest business school in the South. Originally located on Common Street in the business district, Soulé College moved in 1874 to a site across Lafayette Street from Gallier Hall (see p. 52). Here the college would remain until the 1920s, when a demand for larger quarters prompted the move uptown. Soulé College operated in the Garden District until its closure in 1983.

Soulé College stressed penmanship along with mathematical and secretarial skills. George Soulé himself was noted for his superb penmanship, which was reproduced on printed broadsides promoting the school.

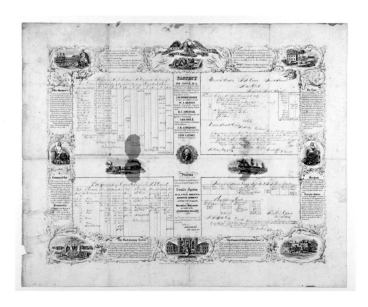

Soulé's Commercial College broadside
1859
George Soulé, designer
J. Manouvrier & Co., lithographer
86-2153-RL
gift of Mr. and Mrs. Ira K. Weil

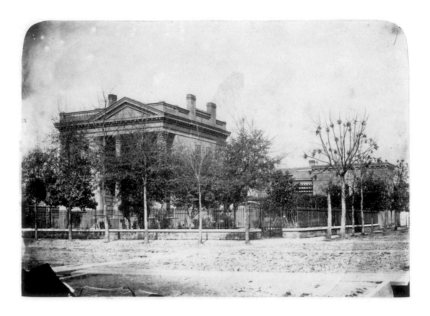

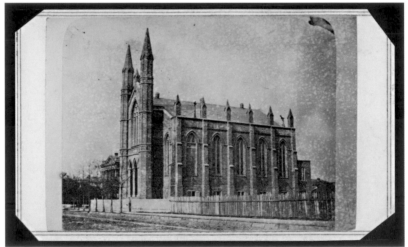

Perkins Residence
between 1858 and 1861; salted paper photoprint
Jay Dearborn Edwards, photographer
1982.32.3

*Saint Ann's Church**
ca. 1864 from an 1858–61 original; albumen print
Jay Dearborn Edwards, photographer; Samuel T. Blessing, photographic printmaker
Marshall Dunham Photograph Album, Mss. 3241, LLMVC-LSU
* *Subject misidentified by Marshall Dunham. The building is the Trinity Episcopal Church.*

THE TWO BUILDINGS PICTURED HERE STILL STAND ON JACKSON AVENUE, ON OPPOSITE SIDES OF COLISEUM STREET. THE HOUSE WAS BUILT AROUND 1850 by commission merchant William M. Perkins, while Trinity Episcopal Church was begun in 1853 but not consecrated until 1866. Just across Jackson Avenue stood the home of Henry Sullivan Buckner. Perkins would sell his home to a member of the Buckner family in 1870—having absented himself from New Orleans during and for a few years after the Civil War.

A line of trees rises above the unpaved street, obscuring much of the Perkins House. The portion that is visible, however, is recognizable to anyone who has passed the present-day site. The same cannot be said of Trinity Church. Its façade was redesigned and enlarged in the 1890s to create a single, central steeple. In Edwards's photograph, a corner of the Perkins façade peeks out at the left. The two structures are linked by function as well as proximity today: the church bought the former Perkins abode in the early 1980s for use as the Trinity Elementary School.

Louisiana's first Protestant congregation, Christ Church, became incorporated on July 3, 1805, with an act signed by Governor William Charles Cole Claiborne. On November 17, in the Cabildo, Philander Chase, an Episcopal clergyman from New York, presided over the congregation's first service. Trinity Church, established as a congregation in 1847, hosted several annual conventions of the Protestant Episcopal Diocese of Louisiana—including one in 1859, roughly contemporaneous with these photographs.

Journal of the Proceedings of the Twenty-first Convention of the Protestant Episcopal Church in the Diocese of Louisiana
1859
Protestant Episcopal Church, author
B. Albertson, publisher
93-629-RL.18

IN 1850 ENGLISH-BORN, OXFORD-EDUCATED LAWYER
EDWARD BRIGGS BUILT THIS HOUSE ON COLISEUM STREET
AT THE CORNER OF THIRD STREET. IN A NEIGHBORHOOD
of lavish, multi-storied mansions, the four-room, one-story home,
while not small, was modest in comparison. A bachelor, Briggs
probably did not require much space; a rheumatic, he might have
found stair-climbing painful. His house, built on a thick layer of
brick and slate to cut dampness, had a specially designed sunken
marble bathtub. The lot covered a quarter of a square block, and the
superb garden was noted for its oak trees and flower beds.

Cast-iron ornamentation was the height of local architectural
fashion in the 1850s. New Orleans had several foundries, although
cast-iron pieces manufactured elsewhere were obtainable through
catalogues. Briggs's fence—with its unfussy crossed design—
contrasted with the ornate style then in vogue. Into the twentieth
century, similar ironwork could be bought locally at wire and
ironwork dealers such as S. Nosacka & Son (812 Bourbon Street).

After Briggs's death in 1868, his house was purchased the
following year by Newton Buckner—the second son of Henry
Sullivan Buckner, whose home was just
four blocks away on Jackson Avenue. The
younger Buckner had architect William
Freret enlarge and completely remodel
the house, leaving little of the original
except the footprint. A second floor and
mansard roof were added, and the cast-
iron supports on the veranda were replaced
by heavy square columns. In the 1920s the
lot was subdivided to make way for several
smaller houses, prompting the demolition
of the Briggs-Buckner structure.

Nosacka Ironworks Catalog
ca. 1910
S. Nosacka & Son, publisher
81-090-RL
gift of Henry Alcus

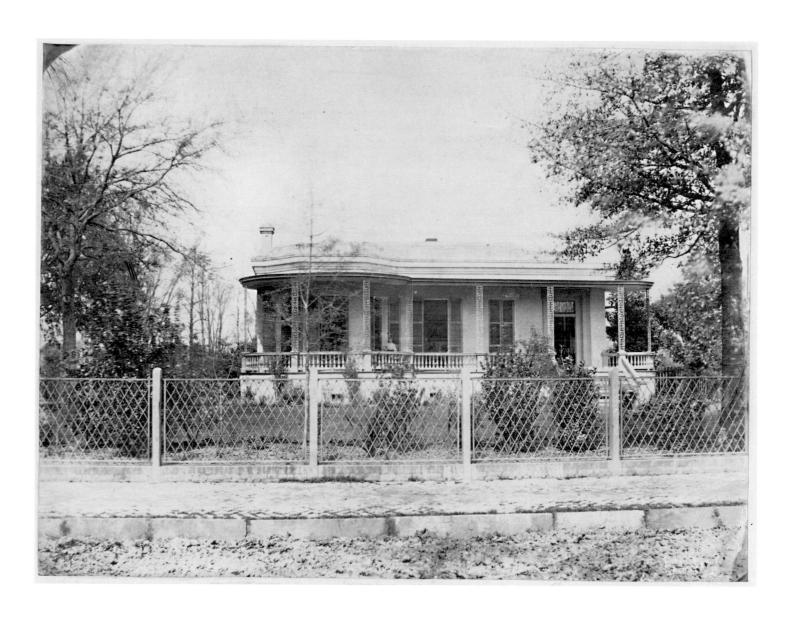

Edward Briggs Residence
between 1858 and 1861; salted paper photoprint
Jay Dearborn Edwards, photographer
1982.32.12

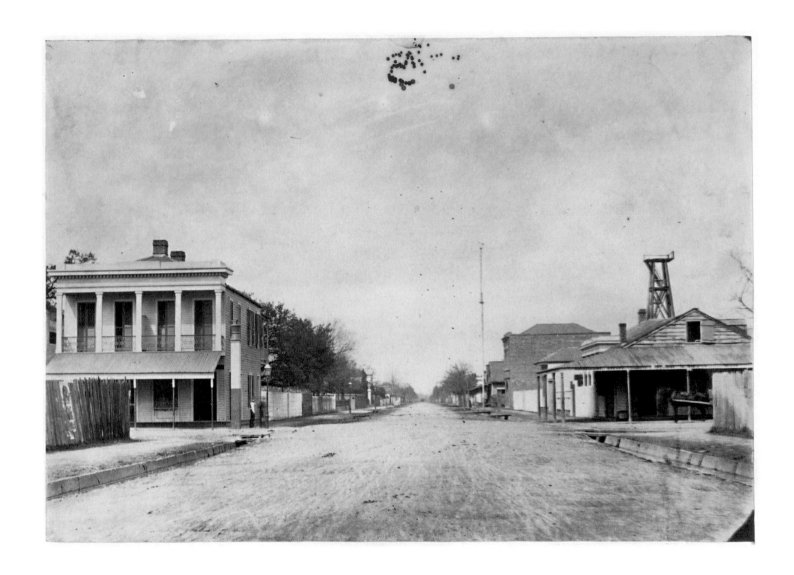

Washington Street
between 1858 and 1861; salted paper photoprint
Jay Dearborn Edwards, photographer
1982.32.4

A 1996 REPORT IDENTIFIED "WASHINGTON" AS THE SEVENTEENTH MOST POPULAR STREET NAME IN THE UNITED STATES. NEW ORLEANS'S OWN WASHINGTON Street (now Avenue)—seen in this photograph—was laid out in 1835 when the former Livaudais plantation tract was carved into streets, squares, and building lots to create the fledgling city of Lafayette. Washington was the broadest thoroughfare in the new development. Its generous expanse, flanked by deep gutters and wide sidewalks, may be slightly exaggerated in this photograph by use of the selected lens. The street's dusty surface bears the tracks of many carriages, wagons, and draft animals, which could pass easily when the street was dry but only with great difficulty after heavy rains. The intersecting street, crossing from left to right, is Magazine Street.

By the time this photograph was made, Lafayette had been incorporated into the city of New Orleans as the Fourth Municipal District. But not all city services were unified—as evidenced by the lookout tower of Chalmette Fire Company N° 23. Volunteer fire companies had operated throughout New Orleans since 1829. Not until 1892 did the city create a paid, professional fire department. A fire trumpet, similar in form to the ceremonial example shown here, was standard nineteenth-century firefighting equipment. Typically used as a megaphone, it could serve other purposes in a pinch: one 1860 *Picayune* account noted that an onlooker interfering with a firefighter's work was "felled with a fire trumpet."

Fire trumpet
ca. 1870; silver plate
1980.184
gift of Mr. and Mrs. Solis Seiferth

Edwards mounted the lookout tower at the Chalmette Fire Station (see pp. 84–85) to aim his camera downriver across Camp Street, which intersects Fourth Street at the lower left of the picture. St. Patrick's Church is visible to the far left of the frame. (The curving course of the Mississippi, and those streets that parallel the river, is dramatically illustrated by the fact that St. Patrick's shares a Camp Street address with the houses in the photograph's foreground.) The next notable structure along the skyline is the belvedere of the Buckner House (see p. 78). In the hazy distance a bit to the right are St. Paul's Episcopal and St. Theresa's Catholic churches; closer by are the towers of Trinity Episcopal Church (see p. 80). The belfry of Coliseum Place Baptist Church rises near the center of the skyline, while ships' masts stretch along the horizon to the right.

Frame houses enclosed by picket and plank fences recall the earlier, less glamorous days when this neighborhood belonged to the independent City of Lafayette. By the mid-1850s the countrified blocks of the newly minted "Garden District" were rapidly filling

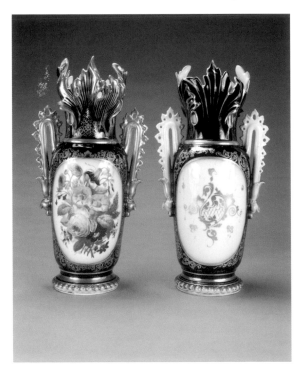

with fine new houses—most financed through cotton, insurance, shipping, and other ventures tied to the city's booming port. Elaborate furnishings and adornments were the norm for Garden District mansions. Typical of the time is this pair of mid-nineteenth-century "Vieux Paris" porcelain mantel vases. Vieux Paris, usually unsigned, was initially produced by a variety of Parisian manufacturers. Widely imitated, it epitomized the period's taste for ornate, elaborately painted and gilded ornaments.

Pair of "Vieux Paris" mantel vases
ca. 1855; parcel-gilded and polychrome enameled porcelain
1996.121.1–.2
gift of Capt. and Mrs. F. Winter Trapolin in memory of
Mr. and Mrs. Jean Baptiste Trapolin

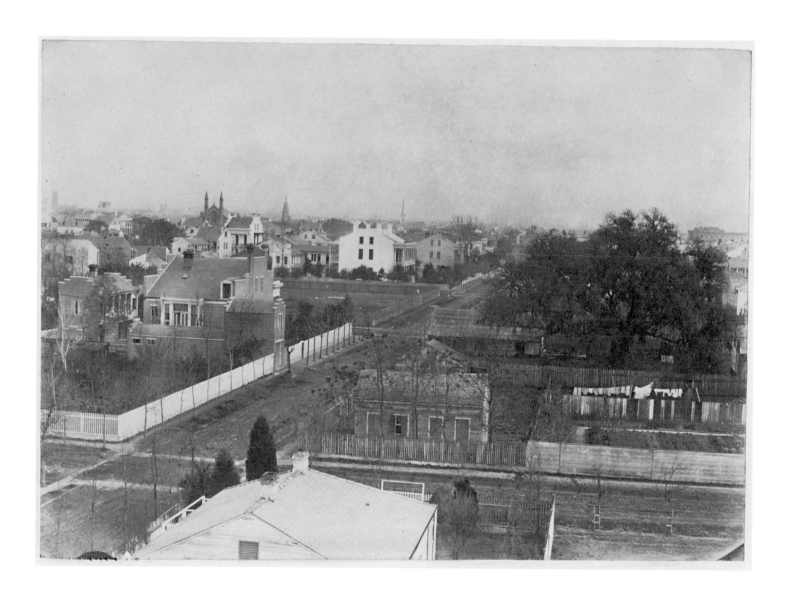

Bird's-Eye View of Garden District from Fire Tower
between 1858 and 1861; salted paper photoprint
Jay Dearborn Edwards, photographer
1982.32.9

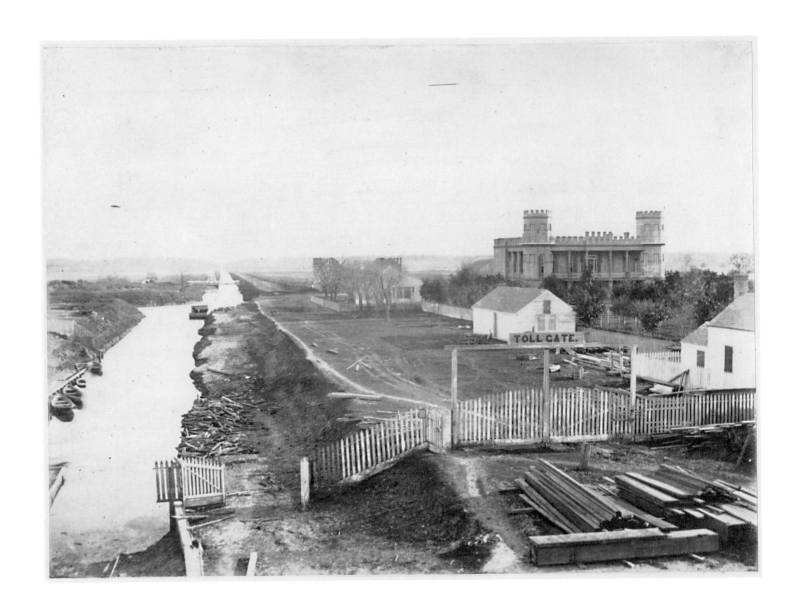

Harvey's Canal and Harvey's Castle
between 1858 and 1861; salted paper photoprint
Jay Dearborn Edwards, photographer
1982.32.11

Situated between the Mississippi River and Lake Pontchartrain, New Orleans has long depended on navigation canals for the transport of waterborne cargoes. The earliest, the Carondelet Canal, connected the Vieux Carré to Bayou St. John in the mid-1790s. Other canals served agricultural purposes. Within decades of the city's founding, plantation owners had begun dredging drainage canals to boost the arability of swampy land. Regular flooding and urban expansion produced a web of drainage canals during the nineteenth and twentieth centuries.

The subject of this photograph is a canal on the west bank of the Mississippi River, opposite New Orleans. Begun in 1835 for drainage and dubbed the Destrehan Canal, the channel was greatly widened and deepened by local developer Joseph Hale Harvey in 1853, making it suitable for navigation. The canal connected Bayou Barataria to a point very near the Mississippi River. A toll gate boldly declared the waterway a commercial venture.

The channel and its towpath take a visual back seat, in Edwards's photograph, to Harvey's Castle, an early local embodiment of revival-style architecture. A penchant for referencing classic design elements yielded buildings based on Greek, Egyptian, and (as seen in this example) Gothic precedents. The castle was completed in 1844 as a gift for Harvey's wife, Louise Destrehan, and demolished in 1924 for the installation of modern locks on the waterway.

Detail Charts of the Lower Mississippi River from Mouth of the
Ohio River to Head of Passes, Louisiana…(Chart 76)
1894; lithograph
Mississippi River Commission, publisher
1976.67

THE CENTURY PLANT (A TYPE OF AGAVE, NOT A TRUE ALOE) IS NATIVE TO PARTS OF SOUTH, CENTRAL, AND NORTH AMERICA. ITS LEATHERY, OVERSIZED leaves and unusual lifecycle command attention. After years (though not a century) of apparent dormancy, the plant produces a towering stalk, crowned with blooms. Having flowered once, the plant dies, and new ones form at its base.

In addition to its material components—paper, chemicals—a photographic print comprises intangible elements: curiosity, creativity, memory, motive. To "read" a photograph is to open oneself to this invisible content. The two gardeners, here, radiate a clear sense of satisfaction. The emotions of the photographer are less easily discerned. Had Edwards been hired to memorialize a moment of horticultural triumph? Or was he moved not by obligation but by fascination? A botanical marvel, the century plant stands out as exotic even in New Orleans's lush semitropical landscape. In 1871, illustrator Alfred R. Waud sketched a century plant while on assignment for *Every Saturday*. In the mid-1880s, the plant was prominently featured in the Horticultural Hall of the World's Industrial and Cotton Centennial Exposition. And to this day, New Orleans newspapers and television stations trumpet those occasions when a century plant shoots into bloom.

Human dominance over nature is a popular photographic theme. Photographs celebrate the engineering of tunnels, dams,

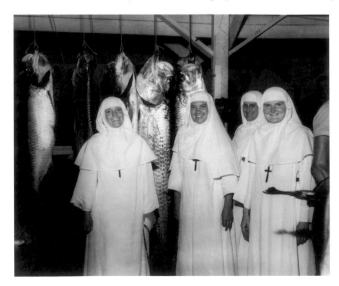

bridges; the scaling of mountain peaks; and, as these proud sportswomen can attest, the landing of a big catch. Edwards's image does not suggest human triumph over nature so much as a related sentiment: human pride in nature's own accomplishments.

Nuns at the Grand Isle Tarpon Rodeo
1960; photoprint
Manuel C. DeLerno, photographer
1974.25.31.191

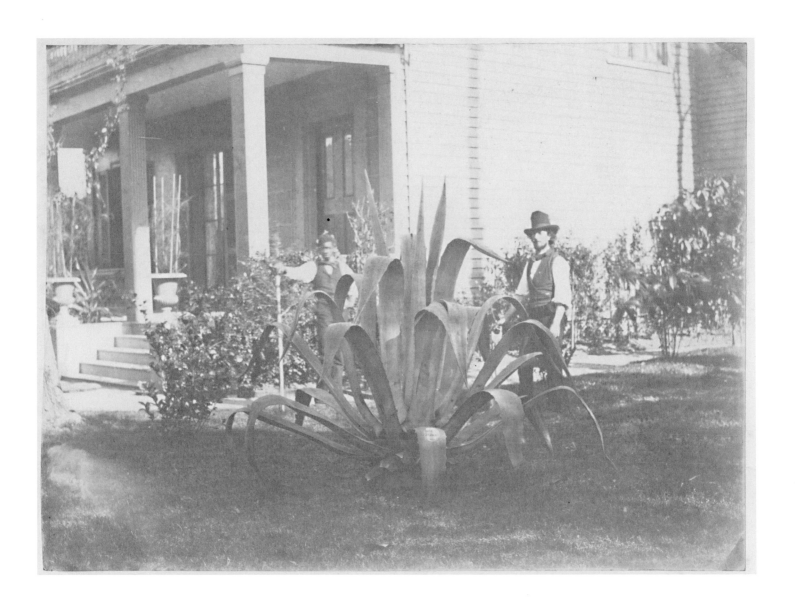

American Aloe or Century Plant
between 1858 and 1861; salted paper photoprint
Jay Dearborn Edwards, photographer
1982.167.4

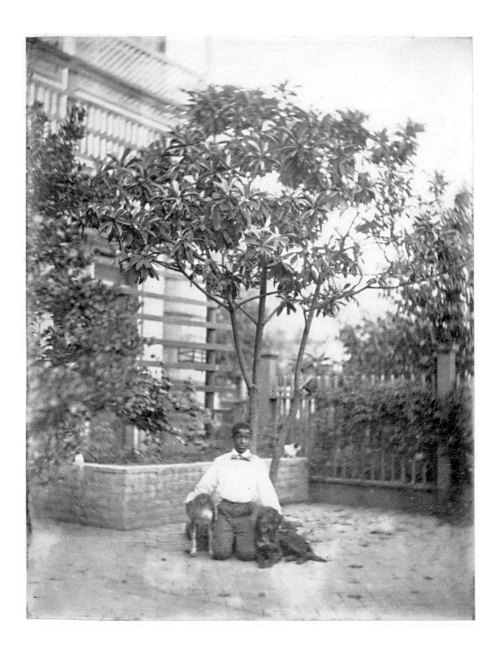

Magnolia Tree [Japanese Plum or Loquat Tree]
between 1858 and 1861; salted paper photoprint
Jay Dearborn Edwards, photographer
1982.167.6

A PENCILED TITLE ON THE MOUNT OF THIS IMAGE—
PRESUMABLY SUPPLIED BY EDWARDS—IDENTIFIES
THE TREE AS A MAGNOLIA, BUT ITS APPEARANCE
suggests the loquat or Japanese plum tree (*Eriobotrya japonica*)
commonly found in New Orleans gardens. The botanical miscue is
only half the story. The applied title is misleading in what it says—
and in what it fails to say. Studying the image, we are reminded that
photographs often raise more questions than they purport to answer.

The tableau presented by Edwards is as charming as it
is enigmatic, its mystery enhanced by the relative scarcity of
contemporary domestic photographs. At the center of the frame,
an African American man holds two dogs by the scruff of their
necks. The one on the right (a spaniel? a setter?) is blurred, having
grown restless during an exposure lasting several seconds. Were
these hunting dogs or family pets? Was the man in charge of them
slave or free? Other details, haphazard and incidental, fill out the
composition. A cat sits atop a brick retaining wall, and what looks
like a bird cage hangs from the trellis. A large building looms to the
rear, but few architectural clues are evident. Taken together, these
details tantalize us with a taste of domesticity. Yet in the end, we
are denied easy intimacy. The open-endedness of the photographic
narrative compels further inquiry.

Over the centuries, photographs have come to serve as a proxy
for absent—or departed—loved ones, both human and otherwise.
Images of beloved pets fill
many a photo album. Journalist
Eliza Jane Nicholson opted
for a different sort of *memento
mori*. She preserved, through
taxidermy, the paw of her
beloved dog, Matt, and had it
mounted as a piece of jewelry.

Dog's paw memorial brooch
ca. 1885; animal remains and metal
81-93-L.1
gift of Elizabeth Nicholson Fischer and Eleanor Nicholson Corbin

THE HISTORIC NEW ORLEANS COLLECTION WOULD LIKE TO THANK THOSE INDIVIDUALS AND INSTITUTIONS WHOSE ASSISTANCE WAS instrumental in completing this exhibition and catalogue on the work of Jay Dearborn Edwards.

The photographer's great-grandson, Dr. Jay D. Edwards, professor of anthropology at Louisiana State University in Baton Rouge, provided critical biographical and family information on his ancestor, as well as portraits, which permit the satisfaction of putting a face with the name.

From Louisiana State University and the Hill Memorial Library we are grateful for the loan of several Edwards photographs. These important items are part of the Marshall Dunham Album housed in the library's Louisiana and Lower Mississippi Valley Collection. Dr. Faye Phillips, associate dean, Elaine B. Smyth, librarian, Mark Ellsworth Martin, associate librarian, and Judy Bolton, head of public services, showed interest in this project from the outset, and generosity in assisting in its completion.

The Louisiana State Museum's Board of Directors and Interim Museum Director Robert Wheat offered the loan of items from the museum's holdings. Director of Collections Greg Lambousy, Curator of Visual Arts Tony Lewis, and Registrar Thomas Lanham provided further advice and assistance.

The J. Paul Getty Museum, through the agency of Steven Gemmel, digital media specialist, supplied the instructional film on the wet collodion process used in the exhibition.

THE HISTORIC NEW ORLEANS COLLECTION

Priscilla Lawrence
EXECUTIVE DIRECTOR

John H. Lawrence
DIRECTOR OF MUSEUM PROGRAMS

Warren J. Woods
COLLECTIONS MANAGER/EXHIBITIONS COORDINATOR

John H. Lawrence, John T. Magill & Pamela D. Arceneaux
EXHIBITION CURATORS

Judith H. Bonner
CURATORIAL CONSULTANT

Amanda McFillen, Rebecca Smith, Jason Wiese, Daniel Hammer, Sally Stassi, Siva Blake,
Mary Lou Eichhorn & Rachel Gibbons
EXHIBITION RESEARCH

Terry Weldon
HEAD PREPARATOR/EXHIBITION DESIGNER

Scott Ratterree
PREPARATOR

Larry Falgoust, Jude Solomon, Douglas Stallmer & Tony Rodgers
INSTALLATION ASSISTANTS

Steve Sweet
GRAPHICS, INTERNET, AND INTERACTIVE

Erin Greenwald & Jessica Dorman
EDITORS

Teresa Devlin and Anne Robichaux
MARKETING

Viola Berman, Maclyn Hickey, Anna Hilderbrandt & Goldie Lanaux
REGISTRATION

Keely Merritt, Teresa Kirkland & Melissa Carrier
PHOTOGRAPHY

Susan R. Laudeman & Eddy Parker
EDUCATIONAL OUTREACH

Alison Cody
CATALOGUE DESIGN